Art in Los Angeles

The Museum as Site: Sixteen Projects

Los Angeles County Museum of Art

Art in Los Angeles
The Museum as Site: Sixteen Projects

Stephanie Barron

Photographs by Robbert Flick

Los Angeles County Museum of Art
July 21–October 4, 1981

Library of Congress
Cataloging in Publication Data

Barron, Stephanie.
Art in Los Angeles.

1. Environment (Art)—California—Los Angeles
—Exhibitions. 2. Conceptual Art—California—
Los Angeles—Exhibitions. 3. Art, Modern—20th
century—California—Los Angeles—Exhibitions.
I. Los Angeles County Museum of Art. II. Title.
III. Title: Museum as site—sixteen projects.
N6535.L6B37 709′.794′93074019493 81-17161
ISBN 0-87587-102-X AACR2

Published by the
Los Angeles County Museum of Art
5905 Wilshire Boulevard
Los Angeles, California 90036-9990

Edited by Jeanne D'Andrea
and Aleida Rodríguez

Designed in Los Angeles
by April Greiman
Assisted by Cheri Gray

Text set in Century Schoolbook
and Helvetica typefaces
by RS Typographics, Los Angeles

Printed in an edition of 6,200 on
Mustang Vellum 50 lb. offset book
by Alan Lithograph Inc., Los Angeles

This exhibition was made possible
by a grant from The James Irvine Foundation.

Contents

On the occasion of Los Angeles' Bicentennial, the Museum's Department of Modern Art presented a two-part exhibition, *Art in Los Angeles*. The first, *Seventeen Artists in the Sixties,* organized by Senior Curator of Modern Art Maurice Tuchman, explored particular aspects of work by a limited number of artists from a decade in which Los Angeles artists achieved national and international acclaim. The second, *The Museum as Site: Sixteen Projects,* organized by Curator of Modern Art Stephanie Barron, focuses on two specific kinds of art that emerged in the last decade and continue to be practiced by many artists who live here: site-related art and installation art.

This is a period of growth for the Los Angeles County Museum of Art, with expansion planned to include a new building for twentieth-century art. Thus, it is particularly gratifying to celebrate Los Angeles and the high level of creativity that its artists continue to exemplify. We thank all of them for their efforts in making this part of the Museum's Bicentennial celebration a success.

Earl A. Powell III
Director

By its very nature, the exhibition *The Museum as Site: Sixteen Projects* has been a collaborative venture. I would like to thank each of the sixteen artists with whom I have worked during the past year to conceptualize, plan, and execute these works. It has been an exciting, rewarding venture and each of the artists has responded with ambition and excellence to the invitation to exhibit.

Director Earl A. Powell III has been a vocal enthusiast of this project from its inception and through the many months of installation as the artists "invaded" the Museum grounds. Assistant Director for Museum Programs Myrna Smoot balanced the budgeting aspects of the projects, responding with sensitivity to unexpected problems. Head of Technical Services James Kenion deserves special recognition for working with the artists to execute their pieces. Frequently solving seemingly insurmountable dilemmas, Mr. Kenion and the Technical Services, Construction and Maintenance staffs of the Museum responded with understanding and imagination time and again during the past year. Museum photographer Larry Reynolds collaborated with John Baldessari in the execution of his photographic installation.

In the Department of Modern Art, I would like to thank my colleague Maurice Tuchman, Senior Curator of Modern Art, for his unfailing encouragement throughout this undertaking. He was always available to me and to the artists for consultation. Assistant Curator Katherine Hart and Departmental Assistant Lora Brown worked closely with me in all phases of the installation of the projects. Departmental secretary Donna Wong, with great skill, enthusiasm, and diplomacy, took on the additional responsibilities of navigating our department and the sixteen artists through the past year.

This catalog is the result of the efforts of photographer Robbert Flick and designer April Greiman. Mr. Flick worked with rigor, spirit, and zealous commitment to record the process of creation of each of these works. Rarely does one find a photographer who responds so sympathetically and unstintingly. My thanks also go to Curatorial Assistant Stella Paul, Head of Publication and Design Jeanne D'Andrea, Publications Associate Aleida Rodríguez, Museum Service Council volunteer Grace Spencer, and to Jack Brogan, Anne Jackson, Vija Celmins, Rosamund Felsen, Christopher Knight, and Lisa Lyons for their cooperation on this project. I would like to acknowledge the examples of Alanna Heiss, Executive Director, Institute for Art and Urban Resources, New York; and Mark Rosenthal, University Art Museum, University of California, Berkeley, whose exhibitions, *Rooms P.S.1* and *Surface as Support,* respectively, have been an inspiration.

To each of the artists and to their assistants I extend my warmest thanks. Their enthusiasm, understanding, imagination, and dedication to this exhibition have made the projects not only feasible, but an exciting collaboration for the Museum. Lastly, I thank The James Irvine Foundation for their support of the exhibition and this catalog.

Stephanie Barron
Curator of Modern Art

Each artist in the exhibition received a participation fee of seven hundred fifty dollars. The Museum assumed the costs of the materials for each project up to a pre-arranged amount. Each artist signed a contract which outlined the responsibilities and work schedule of the Museum and the artist. Both parties also agreed that at the close of the exhibition the materials would either be returned to the artist or dismantled.

Since most of the works in this exhibition cannot impart their full meaning outside of the contexts of their particular sites, we must rely on documentation to share these pieces with broader audiences. While each artist had a definite *a priori* idea about what the piece would look like, it is in the nature of many of these works that only during the final installation did they take finished form. Thus, it was impossible to predict in advance the ultimate appearance of some of the works in the show. For many artists, moving into the Museum space was the culminating step in a long process of preliminary work in the studio. For this reason, the catalog has awaited the opening of the show. Photographer Robbert Flick assiduously documented the process of creation in the studio and in the Museum during the four months prior to the opening. These process photographs are an indispensable part of the record for a show of this nature.

5

Art in Los Angeles

The Museum as Site: Sixteen Projects

Ahmanson Gallery

Frances and Armand Hammer Wing

Leo S. Bing Theater

N
W — E
S

5905 W i l s h i r e B l v d

Los Angeles County Museum of Art

1. **Michael Asher** (b. 1943)

 Sign in the Park, 1981
 Outdoors: On the path between the B. G. Cantor Sculpture Garden and the lake pit in Hancock Park
 h: 11⅜ in.; w: 41¾ in.; d: ¾ in.

2. **John Baldessari** (b. 1931)

 Alignment Series: Two Palms and Two Columns (for Newman), 1981
 Photographic installation
 Two photographs (one color, one black-and-white), each 15 x 10 ft.
 Ahmanson Gallery, third floor

3. **Jonathan Borofsky** (b. 1942)

 I Dreamed a Dog Was Walking a Tightrope at 2,715,346, 1981
 Mixed-media-and-video gallery installation
 Ahmanson Gallery, third floor

4. **Michael Brewster** (b. 1946)

 Attack and Decay, 1981
 Acoustic sculpture
 Outdoors: B. G. Cantor Sculpture Garden, east section, near circular staircase

5. **Chris Burden** (b. 1946)

 A Tale of Two Cities, 1981
 Mixed-media gallery installation
 Ahmanson Gallery, third floor

6. **Karen Carson** (b. 1943)

 Rising Rings, 1981
 Acrylic on canvas
 h: 52 ft.; w: 20 ft.
 Outdoors: Ahmanson Gallery, south facade

7. **Robert Graham** (b. 1938)

 Retrospective Column, Part One, 1981
 Wax
 h: 15 ft.; w: 30 in.; d: 30 in.
 Ahmanson Gallery, Plaza level entrance

8. **Lloyd Hamrol** (b. 1937)

 Squaredance, 1981
 Constructed wood sculpture (Douglas fir timbers)
 h: 10 ft.; w: 17 ft.; d: 7 ft.
 Outdoors: Upper Plaza, in front of Leo S. Bing Center

9. **Robert Irwin** (b. 1928)

 An Exercise on Placement and Relation in Parts, 1981
 In each location:
 One steel plate– h: 13 ft., 6 in.; w: 2 ft.; d:
 One steel bar– h: 4 ft.; w: 6 in.; d: 6 in.
 One stainless steel bar–h:13 ft.,6 in.;w:1¼
 a) Wilshire Boulevard entrance; b) Lower Plaza, in front of Founders' Wall; c) Upper Plaza, in front of Frances and Armand Hammer Wing; d) Upper Plaza, in front of Ahmanson Gallery; e) Ahmanson Gallery, third fl

10. **Richard Jackson** (b. 1939)

 The Big Idea, 2, 1981
 3,000 stacked canvases
 diam: 16 ft.
 Ahmanson Gallery Atrium

11. **Jay McCafferty** (b. 1948)

 Between, 1981
 Painting in three panels
 h. of each panel: 52 ft.; w. of each panel:
 Outdoors: Ahmanson Gallery, east facade

12. **Michael C. McMillen** (b. 1946)

 Central Meridian, 1981
 Mixed-media environment
 Ahmanson Gallery, third floor

13. **Eric Orr** (b. 1939)

 Prime Matter, 1981
 Column of flame and fog
 h: 20 ft.
 Outdoors: Upper Plaza, in front of Ahmanson Gallery

14. **Roland Reiss** (b. 1929)

 New World Stoneworks, 1981
 Five objects on five pedestals
 a) Leo S. Bing Theater, lobby; b) Ahmanson Gallery Atrium, under stairs; c) Ahmanson Gallery, Plaza level, near elevators; d) Ahmanson Gallery, third floor, stairwell; e) Ahmanson Gallery, fourth floor, near elevators

15. **Terry Schoonhoven** (b. 1945)

 Generator, (A Study in Copper and Grey), 1981
 Acrylic mural
 h: 11 ft.; w: 11 ft., 2 in.
 Outdoors: Ahmanson Gallery facade, north of entrance

16. **Alexis Smith** (b. 1949)

 Cathay, 1981
 Mixed-media gallery installation
 Ahmanson Gallery, third floor

By the end of the 1960s, the art object *qua* object began to be de-emphasized as artists became increasingly interested in the processes by which art was made and the contexts in which new art could exist. To this end, the seventies has been described as a decade characterized not by one particular style but rather by pluralism, in which the way art looked assumed a myriad of guises. It was a decade in which traditional painting and sculpture took a back seat to the mixed-media environment, massive-scale sculpture, earthworks, video, performance, site-related work, and experiments in sound and light. Recognizing the great diversity of new forms, it became evident that a survey of the seventies in Los Angeles would be an unwieldy and ultimately inconclusive endeavor. Instead, we decided to focus on two of the aforementioned ways of working—the site-related work and the mixed-media environment or installation. These are two kinds of work that are generally difficult to exhibit in a museum context and by definition are not commonly collectible. To link them, I conceived of the Museum itself as site and invited artists to create works specifically for indoor and outdoor spaces and locations. The works would remain on view only for the duration of the exhibition. There is an energy and intensity generated by a work made for a given temporal situation—*a priori* uncollectible, unretainable—that is captured in each of these examples.

Since it opened its doors in the mid-1960s the Los Angeles County Museum of Art has been considered by many artists to be an architecturally awkward and unsympathetic space for contemporary art. Currently, the Museum is engaged in an extensive program of expansion, renovation, and replanning with the architectural firm Hardy Holzman Pfeiffer Associates. At a moment of such great change it seemed appropriate to use the Museum and its grounds to recognize a type of artmaking that has emerged here in the past decade. Several artists have taken the buildings and the grounds and treated them as formal objects which can be explored in a variety of ways. Many of the artists have talked about the desire to alert the viewers to less frequently noticed aspects of the buildings or of the grounds. Curiously, this museum, the Temple of Culture on Wilshire Boulevard, which for so many years has been considered a white elephant, became in the context of this exhibition an aesthetic and intellectual challenge. The experience of encountering a scattering of unusual and sometimes jarring, sometimes playful works of art, or of viewing installations that employ non-art materials or unexpected motifs in nontraditional art spaces, is an unfamiliar one to most museum visitors.

Site-related or site-specific art is art conceived only in relation to a given location and related to it for its context and meaning. Works in this show by Michael Asher, John Baldessari, Michael Brewster, Karen Carson, Lloyd Hamrol, Robert Irwin, Jay McCafferty, and Terry Schoonhoven respond to the extant Museum architecture and landscape, which necessarily determined the physical boundaries of the pieces. While most of the artists responded to the building as a physical site, a few, Michael Asher, Richard Jackson, Michael C. McMillen, and Roland Reiss responded to the "museumness" of the site—the museum as a repository of the history of art. These works vary greatly in their response to the challenge of creating site-related art; several of the artists invited had a history of such work, some did not.

The second aspect of the show is the environments that have been created within the Museum grounds by Jonathan Borofsky, Michael C. McMillen, Alexis Smith, and Chris Burden. These artists have created private worlds by using a variety of media and approaches—drawing directly on the wall, using sculpture, found objects, video, sound, light, and architecture to convey their meanings.

9

Frances and Armand Hammer Wing

Seventeen Artists in the Sixties

TV Monitor

3. Robert Irwin C

9. Robert Irwin B

8. Lloyd Hamrol

14. Roland Reiss

A

Leo S. Bing Theater

A

9. Robert Irwin

4. Michael Brewster

Seventeen Artists in the Sixties

Larry Bell
Billy Al Bengston
Wallace Berman
Ronald Davis
Richard Diebenkorn
Sam Francis
Joe Goode
David Hockney
Robert Irwin
Craig Kauffman
Edward Kienholz
John McLaughlin
Edward Moses
Bruce Nauman
Kenneth Price
Edward Ruscha
Peter Voulkos

Michael Asher

N

W — E

S

Ahmanson Gallery

14. Roland Reiss C, E

elevators

10. Richard Jackson

7. Robert Graham

TV Monitor

14. Roland Reiss B

6. Karen Carson

15. Terry Schoonhoven

9. Robert Irwin D

13. Eric Orr

11. Jay McCafferty

Ahmanson Gallery

3. Jonathan Borofsky

5. Chris Burden

16. Alexis Smith

12. Michael C. McMillen

9. Robert Irwin E

stairwell

elevators

14. Roland Reiss D

2. John Baldessari

P l a z a L e v e l

T h i r d F l o o r

Robert **Irwin**

Born in Long Beach, California, 1928;
lives in Los Angeles.

Attended Otis Art Institute, Los Angeles,
1948–50; Jepson Art Institute, Los Angeles,
1951; and Chouinard Art Institute, Los
Angeles, 1952–54.

*An Exercise in Placement and Relation
in Five Parts,* 1981

In each location:
One steel plate—h: 13 ft., 6 in.; w: 2 ft.; d: 1 in.
One steel bar—h: 4 ft.; w: 6 in.; d: 6 in.
One stainless steel bar—h: 13 ft., 6 in.;
 w: 1¼ in.; d: 1¼ in.
a) Wilshire Boulevard entrance; b) Lower
Plaza, in front of Founders' Wall; c) Upper
Plaza, in front of Frances and Armand Hammer Wing; d) Upper Plaza, in front of Ahmanson Gallery; e) Ahmanson Gallery, third floor

site

Robert Irwin is the only artist who has participated in both parts of the *Art in Los Angeles* show. For more than a decade he has been known as a pioneer of site-related work. Irwin's contribution to this part of the show is *An Exercise in Placement and Relation in Five Parts,* a didactic, clear example of site-related work. In each of five locations, beginning at the Wilshire Boulevard entrance to the Museum complex, continuing through three more outdoor sites, and ending in a gallery in the Ahmanson building, Irwin has arranged three steel elements in different configurations. Each location of Irwin's piece determines the formality or informality of the steel configuration. In one, the steel pieces lie casually on the ground as raw materials running the risk (intentionally, of course) of being confused with construction materials. In the stark, white-walled gallery, the warm modulation of the raw steel surface assumes a painterly quality; the steel elements are elegant, formal, and highly structured. This piece not only serves to bring together the variety of indoor and outdoor spaces incorporated by this show, but it also relates the two main buildings, thus linking the art of the sixties with the site-related show. Thus, by following the path of this particular work by Irwin, the viewer is introduced to the possibilities and intention of site-related art.

 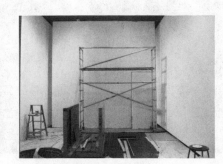

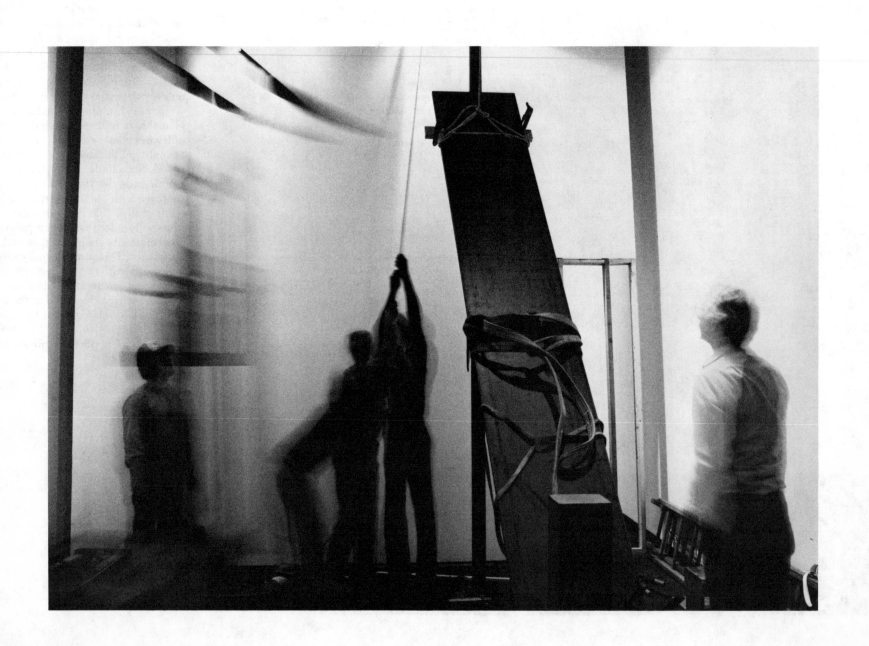

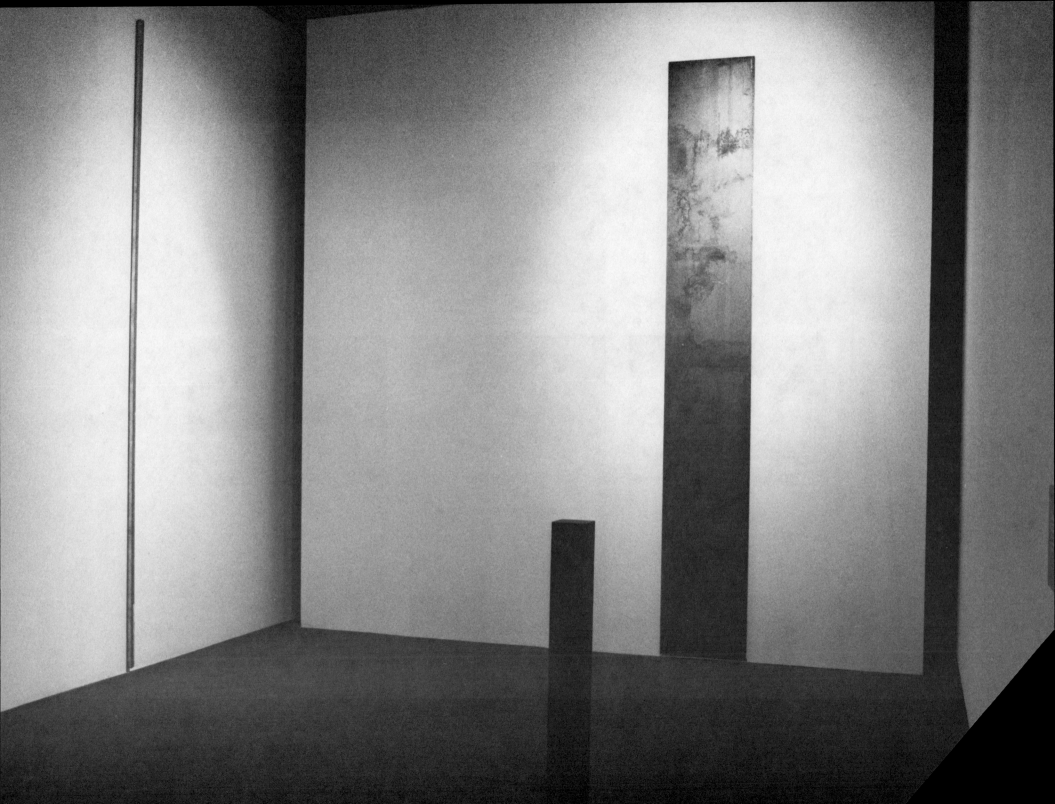

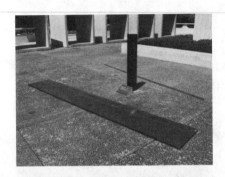

Lloyd **Hamrol**

s i t e

Born in San Francisco, 1937;
lives in Venice, California.

B.F.A., University of California,
Los Angeles, 1959; M.F.A., 1963.

Squaredance, 1981

Constructed wood sculpture (Douglas fir timbers)
h: 10 ft.; w: 17 ft.; d: 7 ft.
Outdoors: Upper Plaza, in front of Leo S. Bing Center

Lloyd Hamrol's sculpture *Squaredance* is a wooden propylaeum located on the Plaza near the entrances to the three "Temples of the Museum": the Ahmanson Gallery, the Frances and Armand Hammer Wing, and the Leo S. Bing Center. Composed of sixty-eight interlocking Douglas fir timbers which are cut from twelve-inch by twelve-inch logs, the four-doored, open-roofed structure is seventeen feet square and nine feet high. Hamrol's sculpture introduces the notion of structure on the Plaza, relates to the three buildings, and yet is in striking contrast to them. Visually, texturally, and gesturally, the rough-hewn wood surfaces and playfulness of the concept set up a contradiction with the three other buildings. While the Museum buildings are vertical, rectilinear, and static, this piece is horizontal; and with the implication of movement made by the skewed doorways, Hamrol causes a disorientation in the viewer. The skewing of the entrances to *Squaredance* produces an unusual, discomforting effect when the viewer is inside looking out at the Museum complex. From the inside, the work's vertical relationship to the Plaza seems reinforced; from the outside, the work appears unbalanced in its spatial orientation. *Squaredance* is a work that examines its site at the Museum, addresses the cumulative architecture of the three buildings, and attempts a dialogue with them.

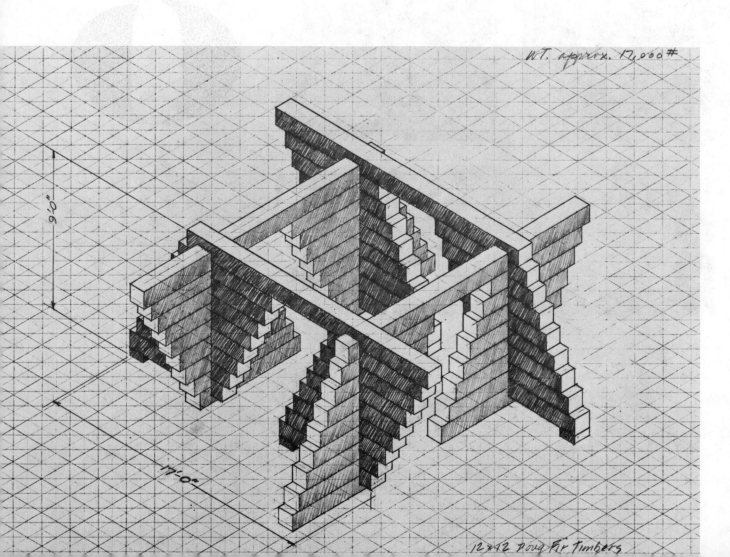

WT. approx. 12,000#

9'-0"

17'-0"

12×12 Doug Fir Timbers

15

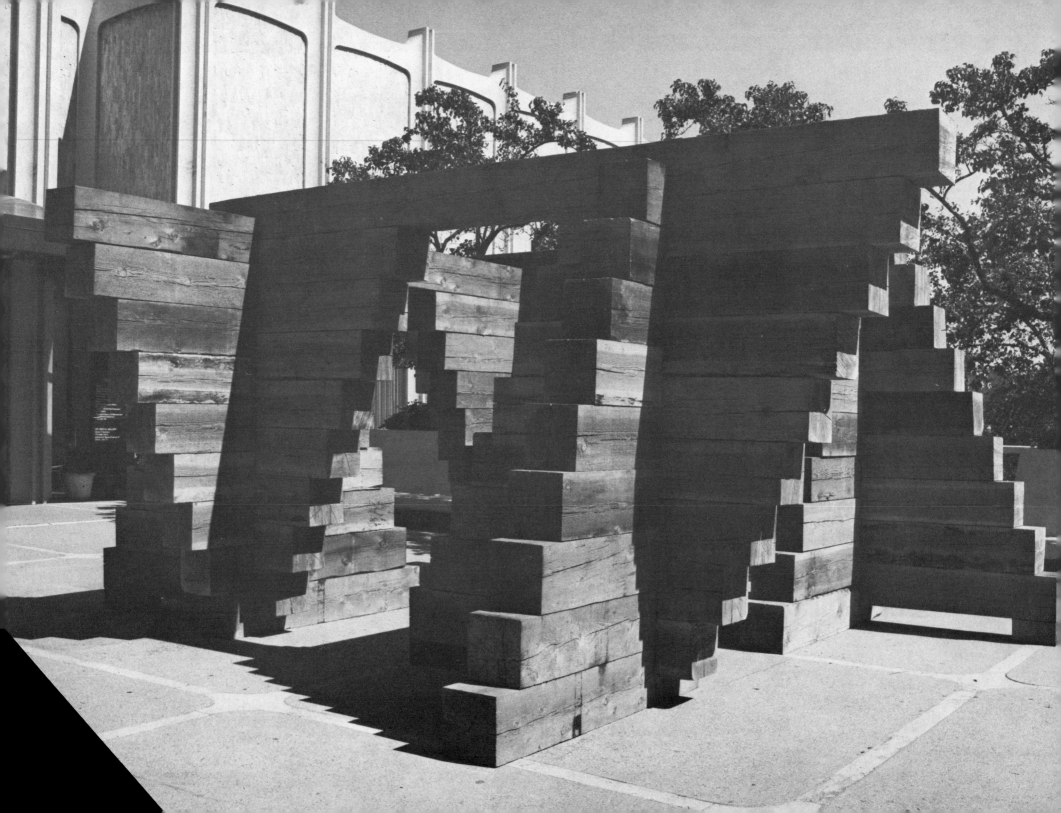

Terry **Schoonhoven**

Born in Freeport, Illinois, 1945;
lives in Los Angeles, California.

B.S., University of Wisconsin, Madison, 1967.
Co-founder, Los Angeles Fine Arts Squad, 1969.

Generator (A Study in Copper and Grey), 1981

Acrylic mural
h: 11 ft.; w: 11 ft. 2 in.
Outdoors: Ahmanson Gallery facade, north
of entrance

Muralist Terry Schoonhoven has created a painting that has as its subject the building facade. Alone, and as a member of an art group called the L.A. Fine Arts Squad, Schoonhoven in the past few years has created several large- and small-scale murals in the Los Angeles area, which respond to the environment in arresting, humorous, and critical ways. At the Museum, Schoonhoven painted *Generator (A Study in Copper and Grey),* a *trompe l'oeil* scene, directly onto the east facade of the Ahmanson Gallery, immediately to the right of the entrance. The image he selected is what one would see if positioned directly in front of the mural and then turned ninety degrees to the left toward Wilshire Boulevard. Schoonhoven responds directly to a given architectural site. Here, he takes the strong architectural detailing—rigorous columnation occurring at intervals—and uses it to his advantage. By subtly altering the viewer's perception of the space, in this instance by clever disorientation, Schoonhoven calls attention to an otherwise undistinguished part of the building. The eleven-foot-square acrylic mural shimmers with a luminescence partially caused by the layering of paint and the textured stucco surface provided by the wall. He in effect punches a hole through the monochromatic, otherwise bland, gallery wall with his loggia within a loggia. His mural bears a strong relation to those of the Renaissance masters—in both his traditional method of working and in his fascination with and concentration on the effects of perspective.

Large-scale outdoor mural painting has recently attracted widespread interest in Los Angeles and throughout America. Often highly colorful antidotes to impersonal urban architecture, they appear on the sides of parking lots, banks, fences, and along roadsides. It has become a "people's art," sometimes involving scores of community participants in a single project. Frequently, mural subjects are drawn from characters or incidents of contemporary life. The murals are for the most part temporal, lasting only as long as the landlord, the painting material, or the neighborhood graffiti permit. In this exhibition, Schoonhoven creates his "public art" within the confines of the art museum. The success of his project show that it is not just the urban eyesore that can accommodate mural art, but that the sensitive merging of art and architecture can enhance the viewer's feeling for most buildings and spaces.

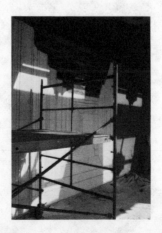

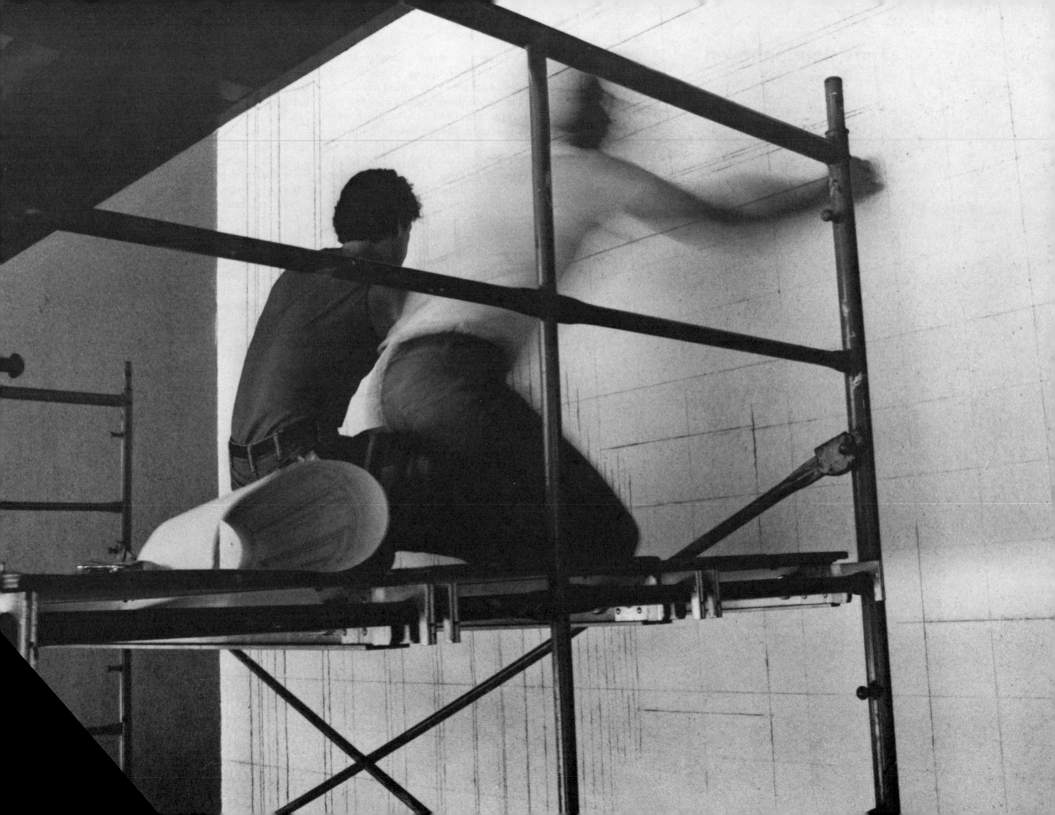

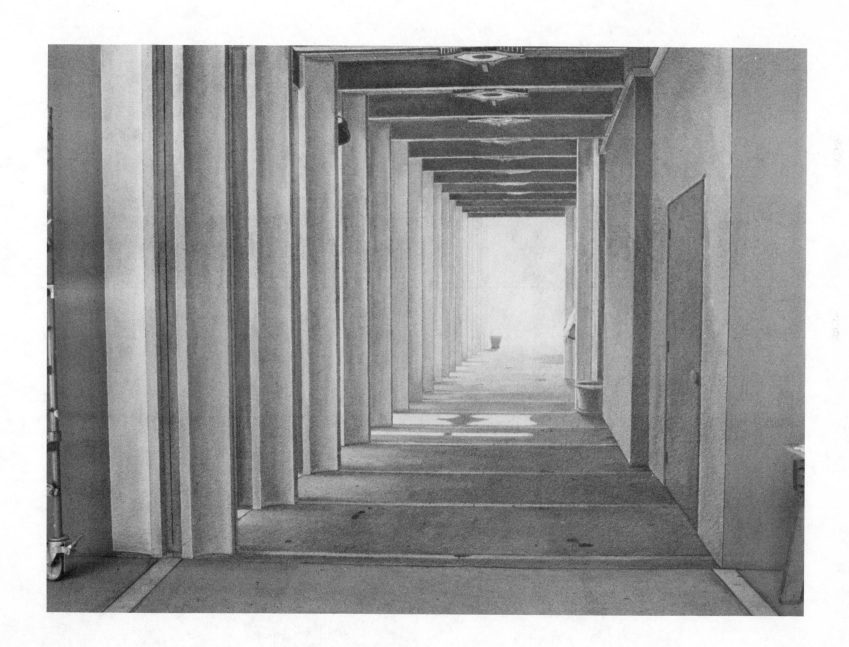

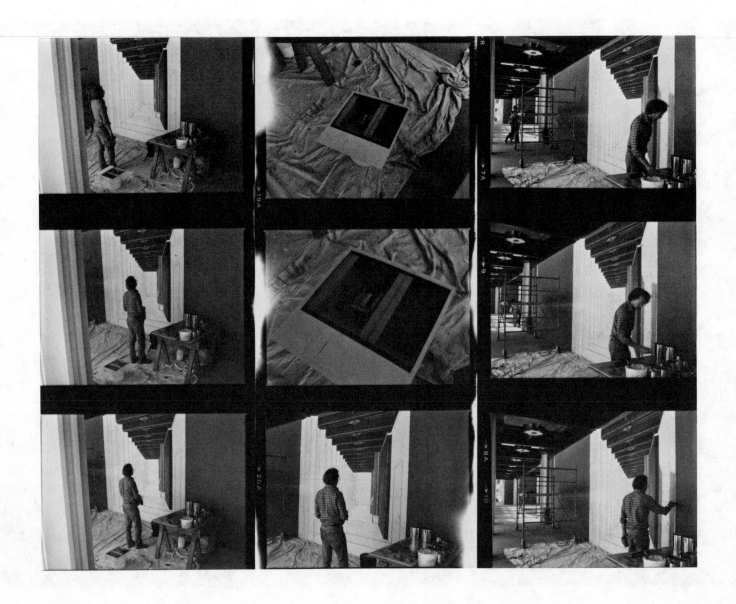

Karen **Carson**

Born in Corvallis, Oregon, 1943;
lives in Venice, California.

B.F.A., University of Oregon, Eugene, 1966;
Claremont Graduate School; M.F.A., University of California, Los Angeles, 1971.

Rising Rings, 1981

Acrylic on canvas
h: 52 ft.; w: 20 ft.
Outdoors: Ahmanson Gallery,
south facade

s i t e

Painter Karen Carson's single fifty-two-foot-high by sixteen-foot-wide canvas, *Rising Rings,* which hangs on the Wilshire Boulevard facade of the Ahmanson Gallery, is a bold and gestural abstract statement. For several years Carson has painted in a manner related to Abstract Expressionism, although for the most part her paintings have remained within a studio scale. In the mid-1970s, she executed a large billboard as part of a series of billboards displayed around Los Angeles sponsored by the Eyes and Ears Foundation. The opportunity to work again with an expansive canvas appealed to the artist, as such occasions are necessarily limited. The proposal to create a fifty-two-foot-high painting to be seen from a distance is a challenge for any artist unaccustomed to such scale, but even more so for one whose work is based on the careful, colorful, and gestural manipulations of surfaces. The fluorescent, saturated coloration that Carson employs in her painting at the Museum plays off the scale of the monochromatic building surface, and the emerging image—rising rings—stands in direct contrast to the austere, rectilinear figuration of the building. It is a remarkable feat that the intimacy of the brushstroke and the dripping paint, characteristic of action painting, have been maintained in a work of this scale—an image to be seen from cars whizzing by on Wilshire Boulevard. Both Carson's and McCafferty's large outdoor paintings deal with the scale of their site and, along with Schoonhoven's mural, take their origin from the architecture and the detailing of the building surfaces.

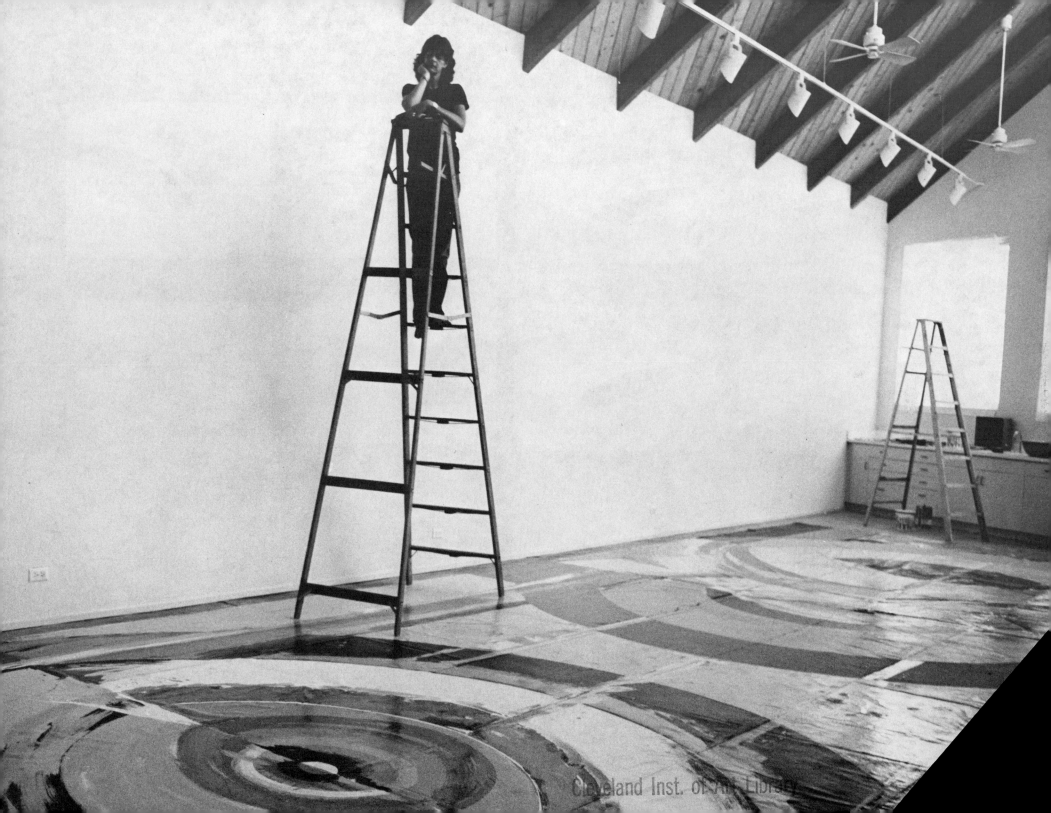

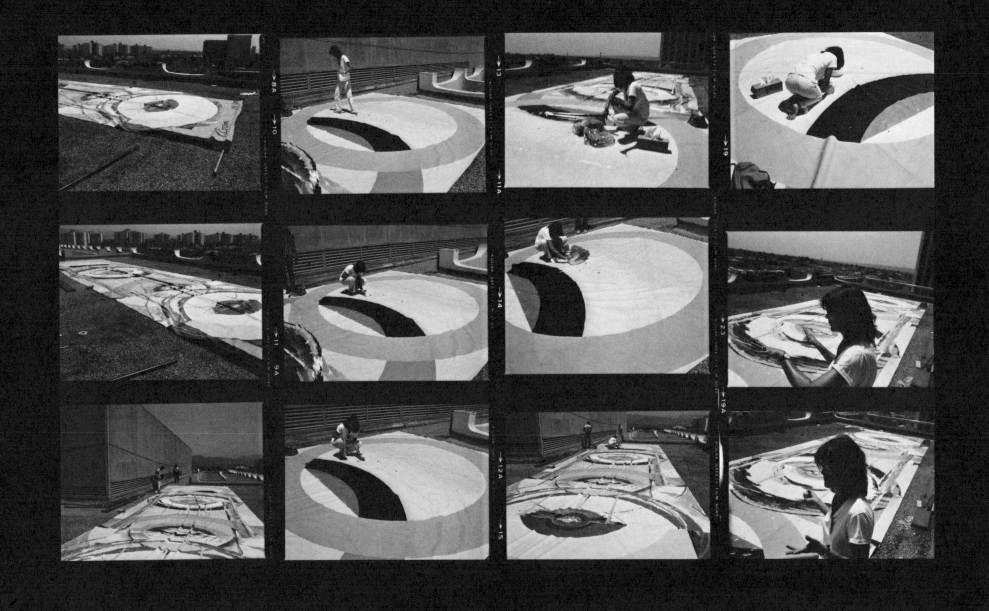

Jay **McCafferty**

Born in San Pedro, California, 1948;
lives in San Pedro, California.

B.A., California State University, Los
Angeles, 1970; M.F.A., University of
California, Irvine, 1973.

Between, 1981

Painting in three panels
h: of each panel: 52 ft.; w: of each panel: 8 ft.
Outdoors: Ahmanson Gallery, east facade

The strong, architectonic detailing of the Museum buildings provided not only Schoonhoven but also painter Jay McCafferty with the impetus for his site-related work. The vigorous columnation that rises over sixty feet and repeats itself across the vast concrete expanses of the Museum could have been an impediment for artists. Instead, McCafferty chose to confront it and make the architecture work for him. His triptych *Between* hangs on the east facade of the Ahmanson Gallery. Each panel of the triptych is fifty-two feet high by eight feet wide, and is installed in alternate bays to the left of the entrance. The brightly colored surface of the three-part painting, rich in line and detailing, was achieved through carefully controlled solar burning, painting, and patching of the immense canvas.

For the past decade McCafferty has worked on paper, using the sun's rays as his medium. On the rooftop portion of his studio McCafferty uses the sun's rays to burn patches, holes, or large abstract areas in a single sheet or in layers of paper. His "automatic" way of making art, which became popular with the Surrealists, has intrigued McCafferty for many years. This triptych is his first work on canvas and his most ambitious project to date.

s i t e

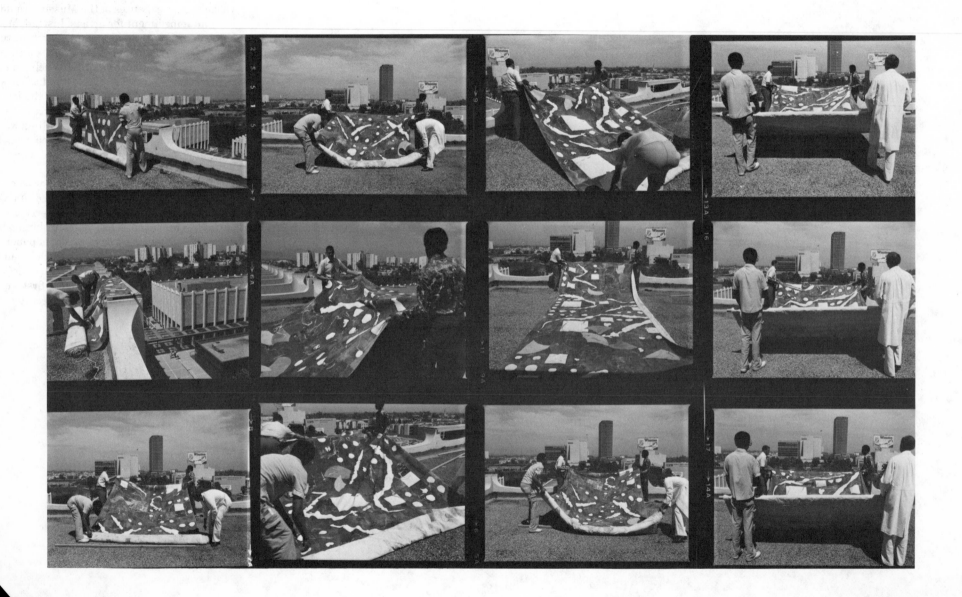

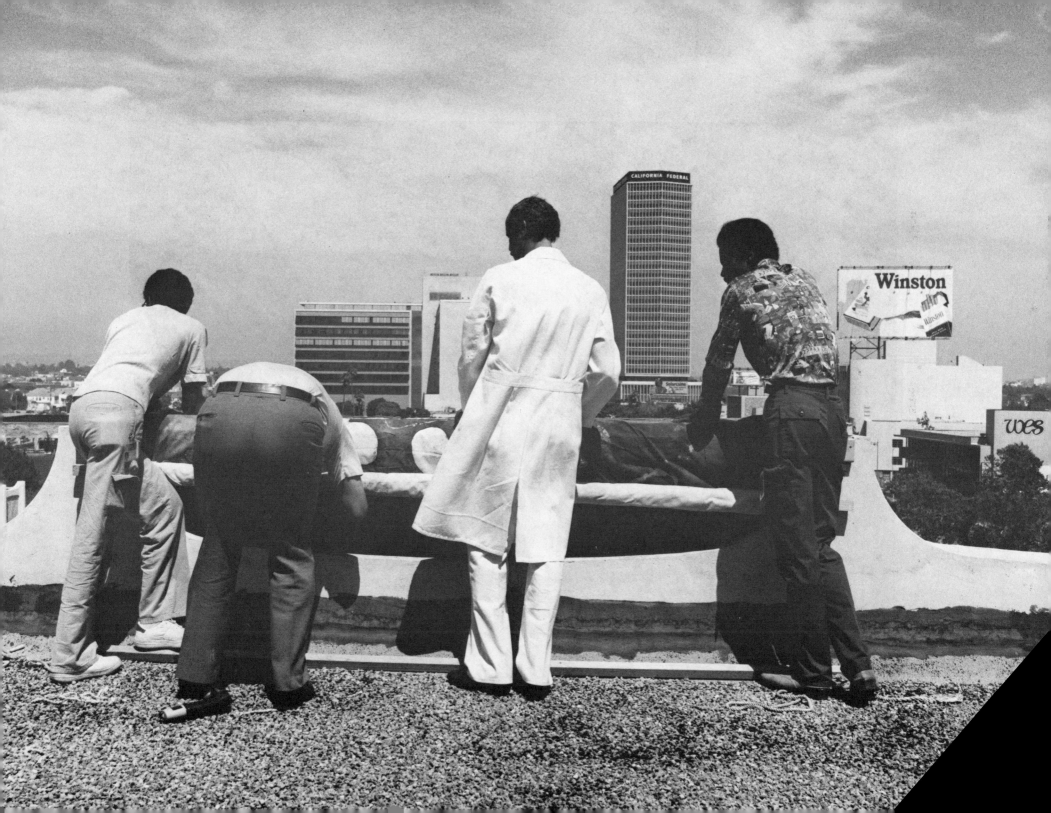

Robert **Graham**

s i t e

Born in Mexico City, Mexico, 1938;
lives in Venice, California.

Attended San Jose State College, California,
1961–63, and San Francisco Art Institute,
1963–64.

Retrospective Column, Part One, 1981

Wax
h: 15 ft.; w: 30 in.; d: 30 in.
Ahmanson Gallery, Plaza level entrance

Robert Graham's majestic fifteen-foot-high wax sculpture, *Retrospective Column, Part One,* is a proposal for one of two columns for the Los Angeles County Museum of Art. Part of the Museum's expansion will include a third-story link between the Frances and Armand Hammer Wing and the Ahmanson Gallery. Graham has proposed that two cast-bronze columns sheath the columns supporting this link; the wax column in this exhibition is the maquette for one of these columns. Recently, Graham has designed large-scale bronze doors and a series of wall panels, each covered with his characteristic figures in half-relief. This work combines an interest in the symbiotic relationship between art and architecture with a self-confident presentation of the body of images he has used in his sculpture during the past fifteen years. Graham's column is an audacious work, containing as it does in its vertical and horizontal registers the history of these images. For centuries, the column has been a fascinating bridge between art and architecture. Renaissance artists covered large-scale bronze doors with dazzling combinations of images. In the late nineteenth century Rodin created the magnificent *Gates of Hell.* For Rodin this magnum opus served for several years as a creative font as he continued to create full-scale sculptures from individual details of the massive gates. For Graham, the *Retrospective Column* functions in reverse as it contains within a single work images that he has already used for many years. It is a strong summary statement for him that merges sculpture and architecture.

31

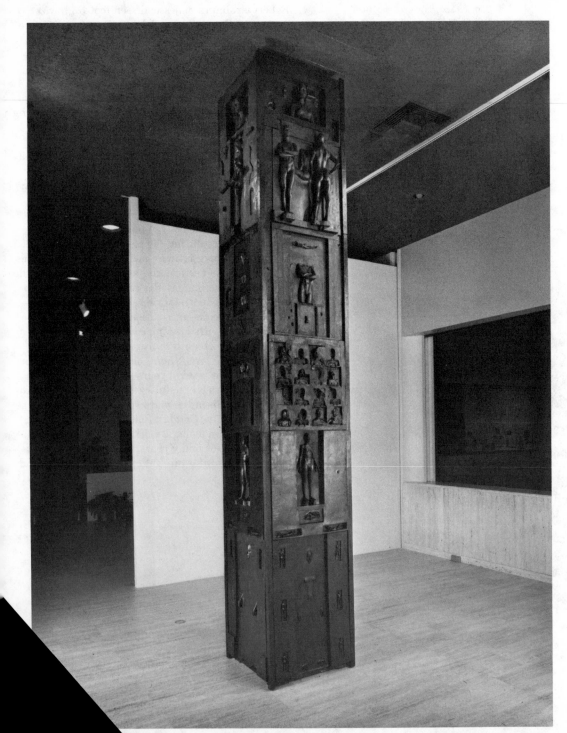

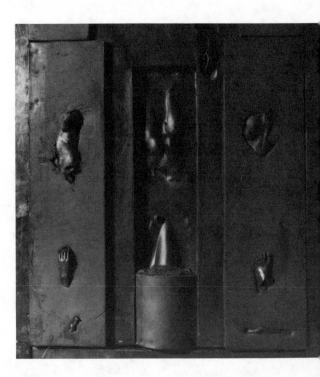

Photographer: Larry Reynolds

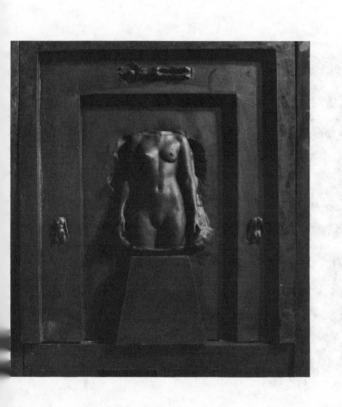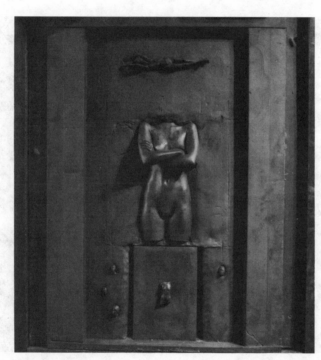

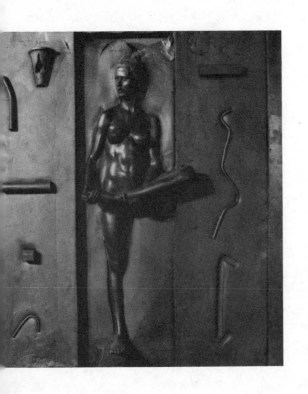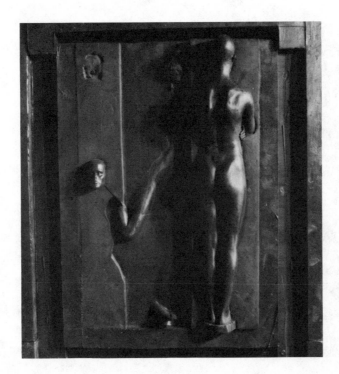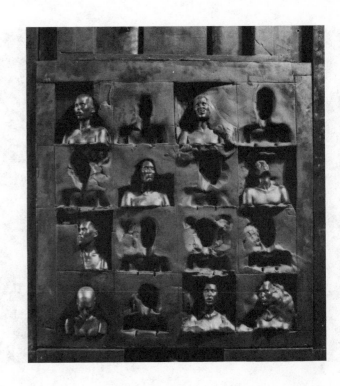

Michael **Asher**

Born in Los Angeles, 1943;
lives in Venice, California.

B.A., University of California,
Irvine, 1966.

Sign in the Park, 1981

Outdoors: On the path between the B. G. Cantor
Sculpture Garden and the lake pit in Hancock Park
h: 11⅜ in.; w: 41¾ in.; d: ¾ in.

site

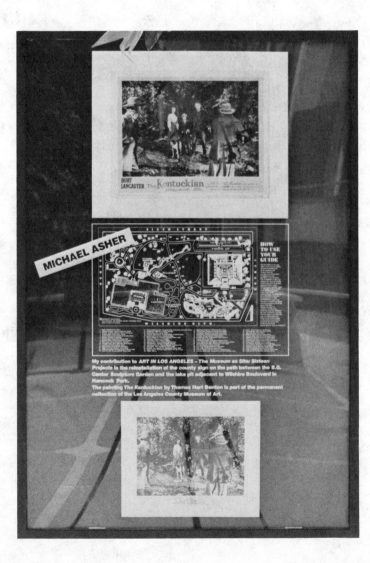

One of the purest examples of site-related work in
the exhibition is by Michael Asher, who for many
years has done conceptual and site-related art that
deals with subtly changing one's perception about
familiar places and subjects. Asher's piece consists
of two parts. The first is the reinstallation of a
"Dogs must be kept on a leash" sign in Hancock
Park. The second part of the piece is a printed
poster, forty by thirty inches, which is on view on
the lower Plaza. The poster depicts a scene in color
and in black and white from the Hollywood movie
The Kentuckian, starring Burt Lancaster. Pictured
in the two stills are Lancaster and a young boy
with a dog on a leash, which relate in a literal way
to the sign in the park. On the poster Asher has
written that 1) his piece for the exhibition was the
reinstallation of a county sign, and 2) the painting
The Kentuckian by Thomas Hart Benton is part of
the Museum's permanent collection. When the
Museum visitor reaches the American art galleries,
he or she can find the *The Kentuckian* on exhibition.

The painting *The Kentuckian* was created for the
film and was owned by Lancaster until he donated
it to the Museum in 1977. Asher's site-related piece
deals with and calls to our attention the reasons for
the creation of this painting and the fact that it
now hangs as part of the permanent collection. He
has used the Museum's site in a very specific way.
His piece does not just deal with the architecture, or
even with the institution's "museumness," but very
specifically with the Los Angeles County Museum
of Art, its own site in Los Angeles, and its relation
to Hollywood.

35

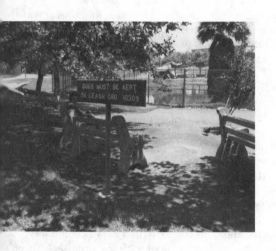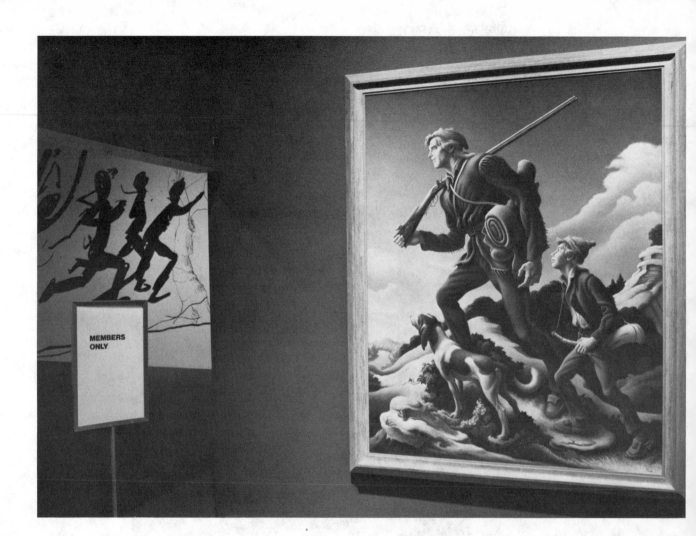

Michael **Brewster**

Born in Eugene, Oregon, 1946;
lives in Venice, California.

B.A., Pomona College, Claremont, California,
1968; M.F.A., Claremont Graduate School,
California, 1970.

Attack and Decay, 1981

Acoustical sculpture
Outdoors: B. G. Cantor Sculpture Garden, east
section, near circular staircase

site

Michael Brewster's acoustic sculpture *Attack and Decay* is an invisible work, free from any encumbering object. Through the medium of live synthetic sound, it describes and defines an outdoor area in the Museum's garden. For the past decade sculptor Brewster has used sound as his medium. While most sculpture is three-dimensional, the viewer is limited to perceiving it from a few aspects. Sound sculpture, by contrast, can be experienced from all directions. The viewer moves through Brewster's sculpture, through its volume, encountering dense and sparse aspects of a seemingly empty space. A distinction that Brewster draws between his acoustic sculpture and contemporary or experimental music is primarily in the viewer's attitude. Brewster's sound sculptures are not meant to be listened to from a single, seated vantage point, as one listens to a concert, but rather they are intended to be experienced as the viewer moves about and through the sculpture. It is this viewer participation that is critical to Brewster.

In *Attack and Decay,* Brewster has constructed a black box which hangs from a tree in the garden, a sound pulsating with an alternating frequency of 1000–1020 Hz. is aimed at the path that traverses this garden. The sound lasts for a few seconds and is followed by a few seconds of silence; the cycle repeats itself continuously during the hours the exhibition is open. Brewster describes the experience of encountering the piece: "It's like walking through swiss cheese, you come to pockets of density (sound) and then move to areas that are punctured (silence), and one can actually walk through this piece." Like light, sound exists spectrally, and each portion of the spectrum exhibits unique qualities. Low frequency sounds have long wave lengths, are volumetric and omnidirectional, and high frequency sounds are monodirectional and linear. Brewster's acoustic sculpture *Attack and Decay* responds to the architectural and volumetric site it inhabits. The sculpture that results is a field of sound volumes of differing sizes, densities, and rates.

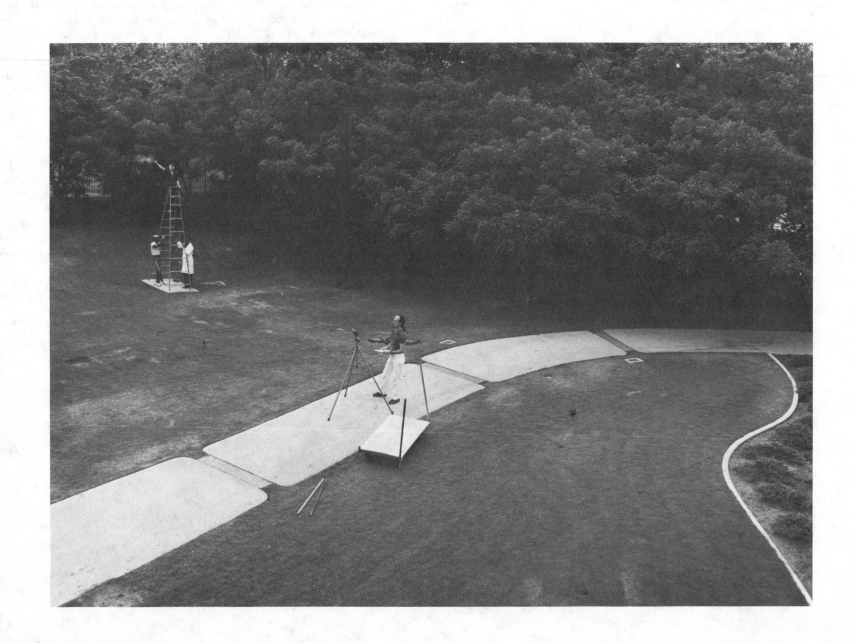

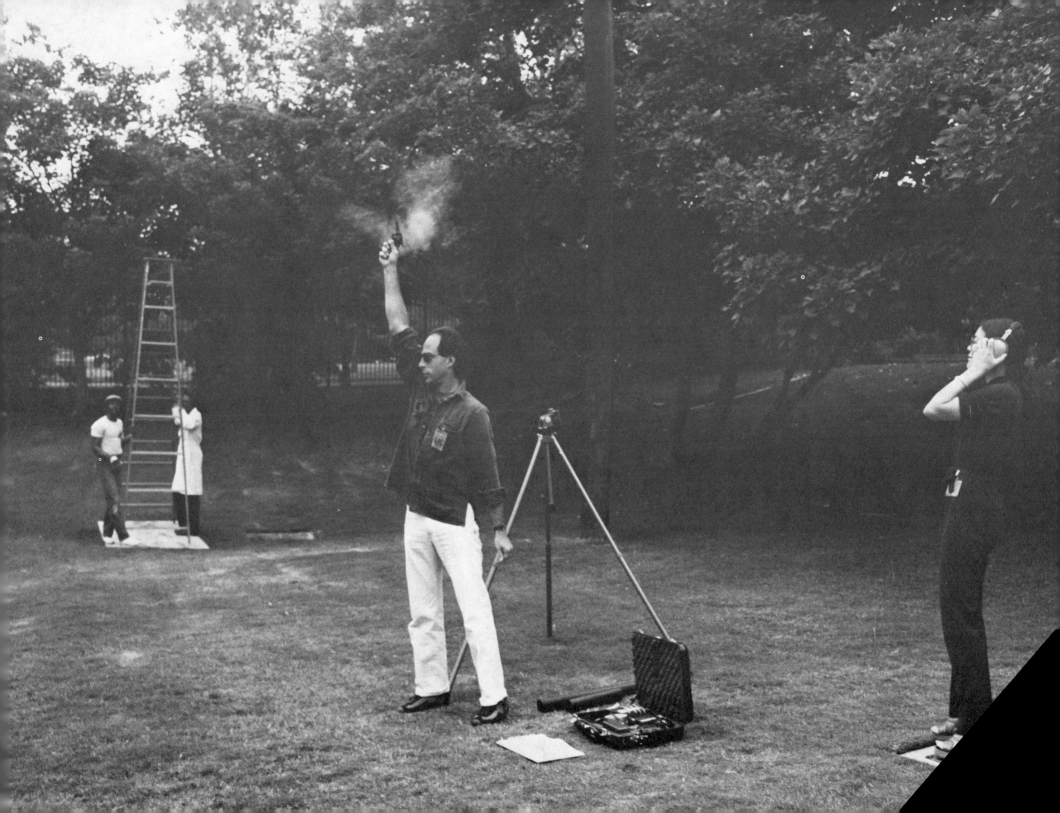

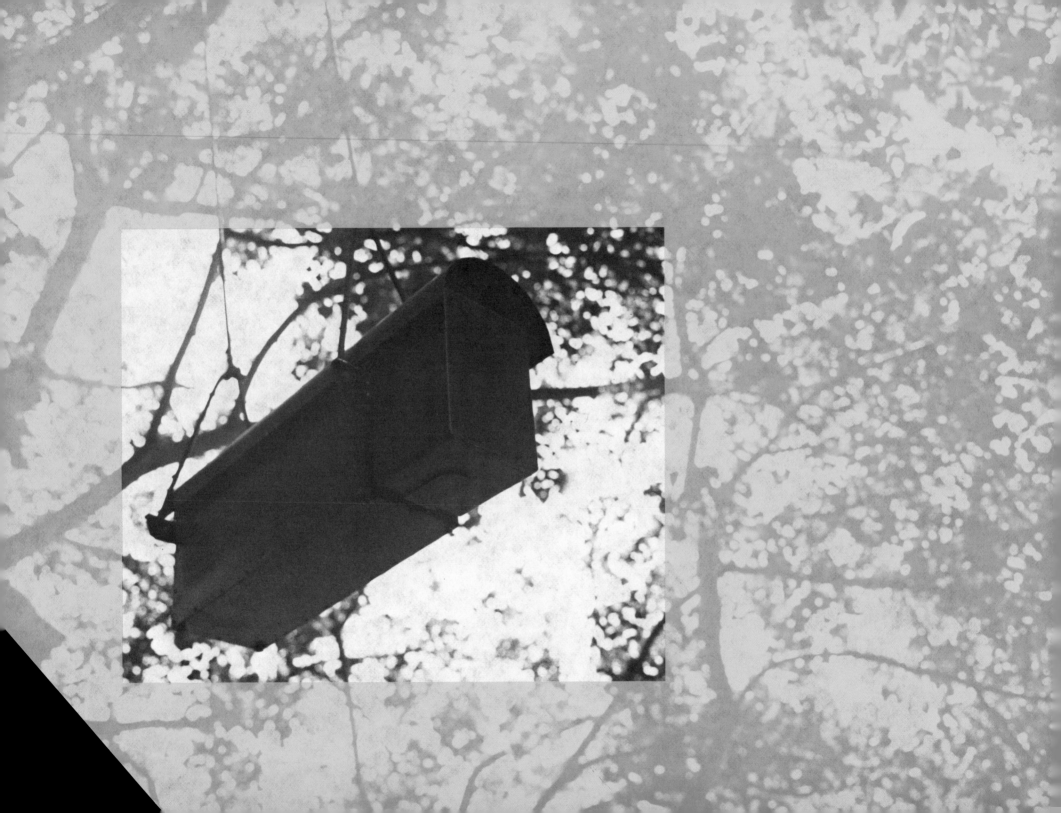

John **Baldessari**

Born in National City, California, 1931;
lives in Santa Monica, California.

*Alignment Series: Two Palms and Two Columns
(for Newman),* 1981

Photographic installation
Two photographs (one color, one black-and-
white) each 15 x 10 ft.
Ahmanson Gallery, third floor

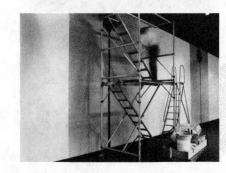

s i t e

2

John Baldessari's photographic installation *Align-
ment Series: Two Palms and Two Columns (For
Newman)* is a witty and effective example of site-
related art. The site Baldessari selected is in the
Ahmanson Gallery, a building which houses the
permanent collection of the Museum. In the center
of the building a large atrium creates a perimeter
of gallery spaces on each of three upper levels. On
the third floor, Baldessari has chosen a gallery that
is seen across the Atrium from the elevator access
to the floor and that also can be viewed at intimate
range. The gallery is punctuated by two floor-to-
ceiling columns. Baldessari chose an architecturally
disparate and awkward space, confronting these
elements with his piece. He has installed two
fifteen-foot-high photographic blowups, one black-
and-white, one color, of a single palm tree. From the
first vista, the viewer sees a floor-to-ceiling gray
rectangle and a blue rectangle, each punctuated or
bisected by a white column of the building. This
zip-like division of the color field recalls the
abstract paintings of Barnett Newman, to whom
Baldessari refers in his title. As one moves six feet
to the right or left, and ultimately around the gal-
lery to the photographs themselves, these two
stark but whimsical trees assume increasing pres-
ence. Conceptual artist Baldessari conceived the
idea for this piece and then worked with profes-
sional photographers, enlargers, and mounters to
execute his work. He has said that he is much more
concerned with the idea than with the physical
process of executing that idea. Although he super-
vises every stage of the project, he does not become
physically involved as a craftsman or technician.
With a single gesture, Baldessari has effectively
activated an otherwise awkward, difficult space
within the Museum.

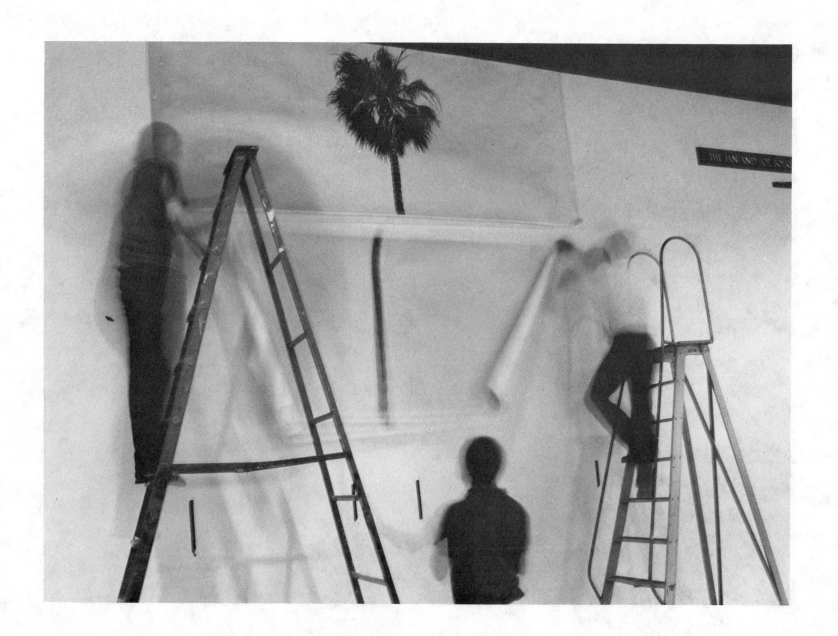

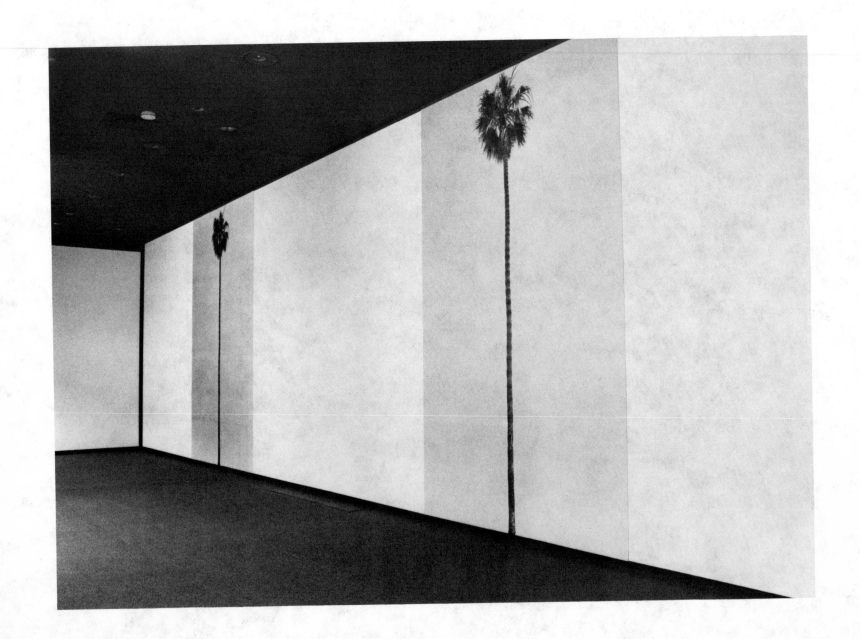

Roland **Reiss**

Born in Chicago, Illinois, 1929; lives in Venice, California.

B.A., University of California, Los Angeles, 1955; M.A., 1957.

New World Stoneworks, 1981

Five objects on five pedestals
a) Leo S. Bing Theater, lobby; b) Ahmanson Gallery Atrium, under stairs; c) Ahmanson Gallery, Plaza level, near elevators; d) Ahmanson Gallery, third floor, stairwell, e) Ahmanson Gallery, fourth floor

Roland Reiss deals with the idea of the "museumness" of his site. In *New World Stoneworks,* Reiss has created five sets of small-scale simulated stone artifacts which he placed in traditional museum pedestal cases and then located in five disparate sites throughout the Museum. Encountering a case containing odd-looking, stonelike palm trees, people, animals, and tract house sliding-glass doors "buried" in the Chinese art galleries next to pedestals containing ancient ritual bronzes is a confounding, humorous, and engaging experience. Reiss' *New World Stoneworks* are a kind of ancient relic of the future; coming upon them in the lobby, stairwell, or among the art of true ancient cultures posits questions in the minds of viewers about the historicity of objects and their context in a museum setting.

Reiss' sculpture employs a variety of contemporary icons that by their juxtaposition within each display case comment on aspects of the culture of the seventies and eighties. As artists in earlier eras had "memorialized" objects and symbols of their cultures, Reiss' sculptures are humorous commentaries on the transitoriness of our lives. The distillation of cultures into selected images or objects has intrigued artists throughout history, and here it becomes the subject of Reiss' work.

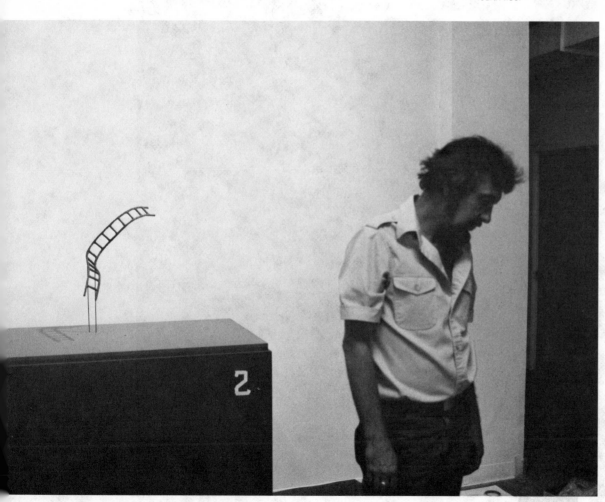

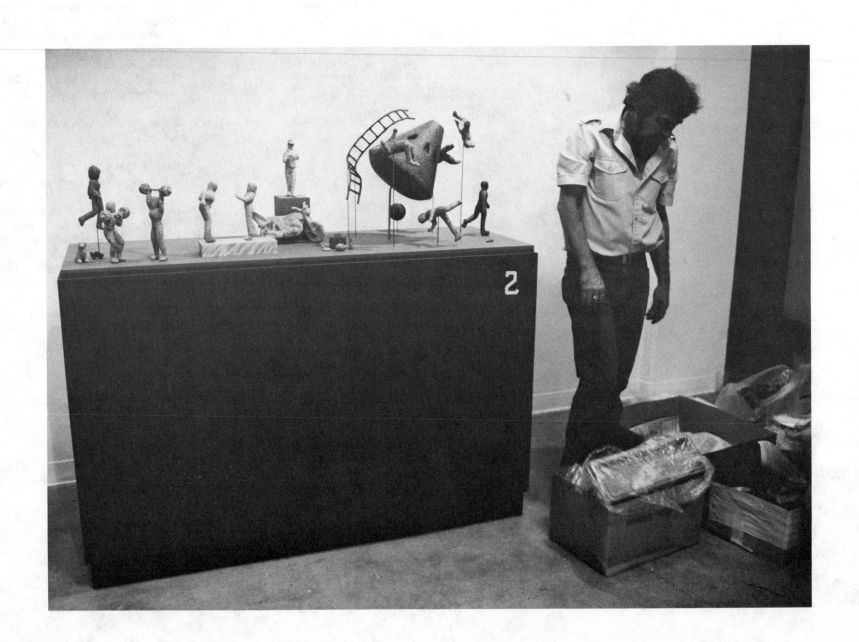

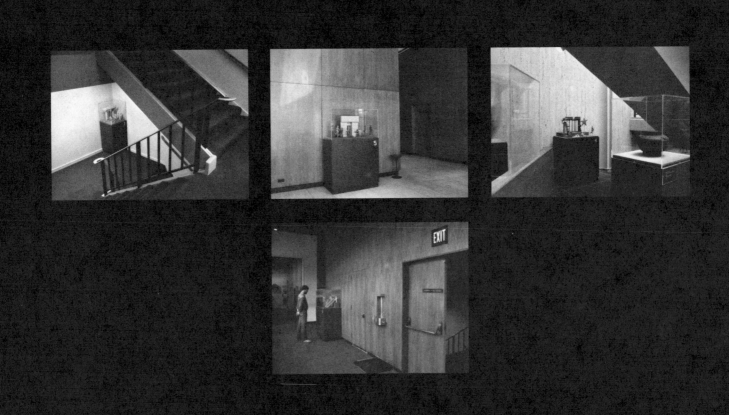

Richard **Jackson**

Born in Sacramento, California, 1939; lives in Pasadena, California.

The Big Idea, 2, 1981

3,000 stacked canvases
diam: 16 ft.
Ahmanson Gallery Atrium

site

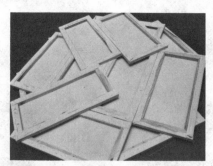

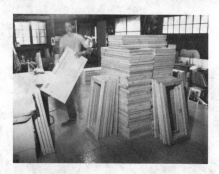

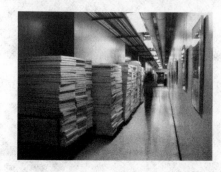

Painter Richard Jackson has created a single monumental painting called *The Big Idea 2,* a sphere constructed of almost 3,000 painted and stacked canvases. Jackson meticulously stretched, primed, and painted each of these canvases, and then stacked each one face down to form a gigantic sphere, sixteen feet in diameter, which is located in the middle of the Ahmanson Gallery Atrium. Initially, *The Big Idea 2* looks like a Magritte come to life, and for many years Jackson has professed a fascination with the Surrealists. For Jackson, as for the Surrealists, the *process* is an essential part of the creation of a work of art. Looking down at *The Big Idea 2* the viewer sees the sphere's platform covered with the paint drips built up in the four weeks it took to assemble the work. Curiously, Jackson approached this painting in a very traditional manner. He stretched each canvas himself and covered each with gesso, even though they were inevitably buried within the mass of the piece. When asked why he works this way, Jackson responds, "That's the only way I know to make a painting!"

Jackson's work suggests a variety of concerns: that all artists make the same painting over and over again, that the museum is the ultimate warehouse, and that art is process. He affirms, too, the attraction the "grand machine" has traditionally held for artists. Jackson's colorful, painterly work is an awesome accomplishment that totally disarms the viewer and provides a humorous and arresting counterpoint to the bland architectonics of the surrounding spaces.

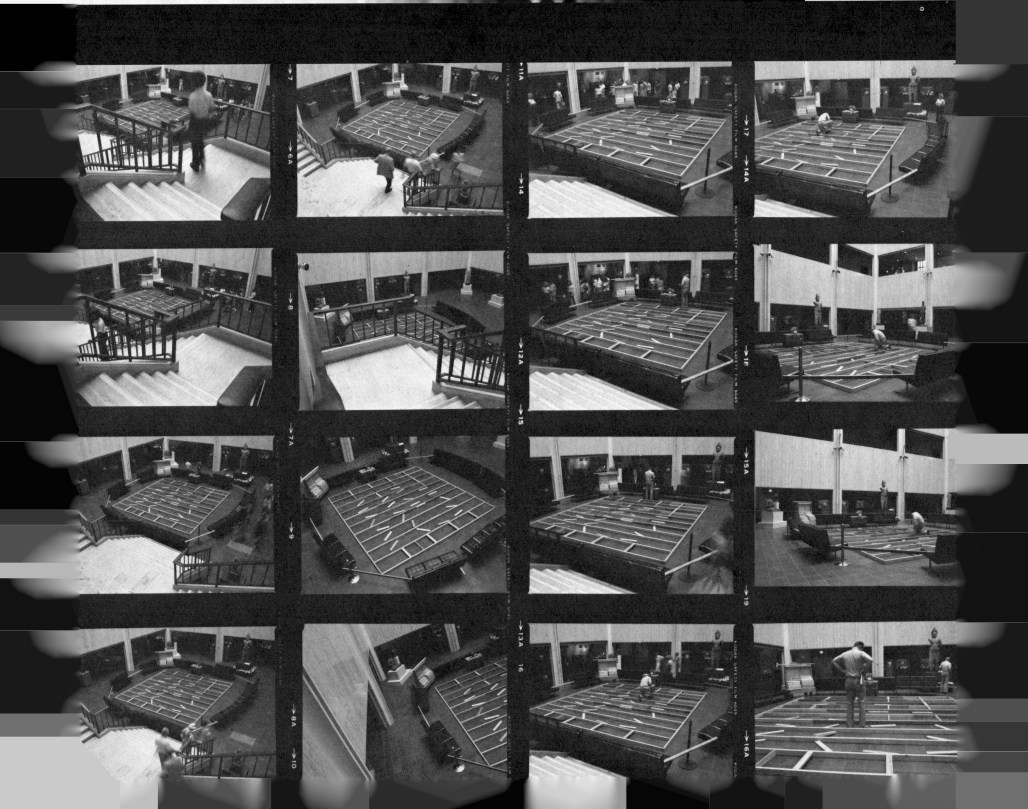

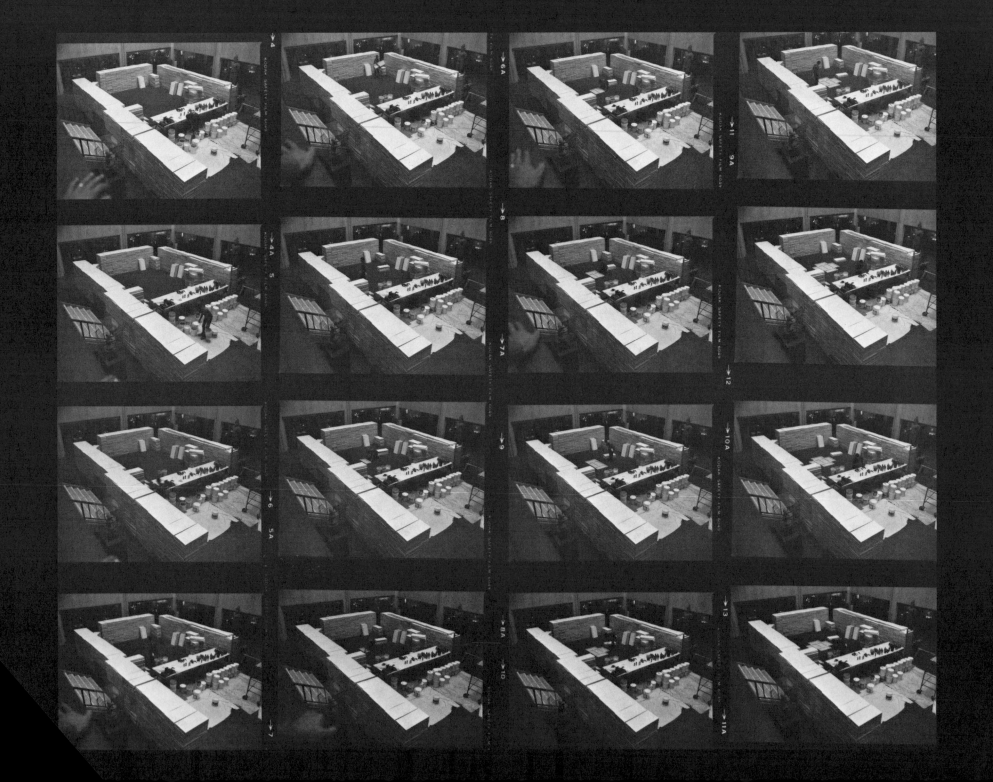

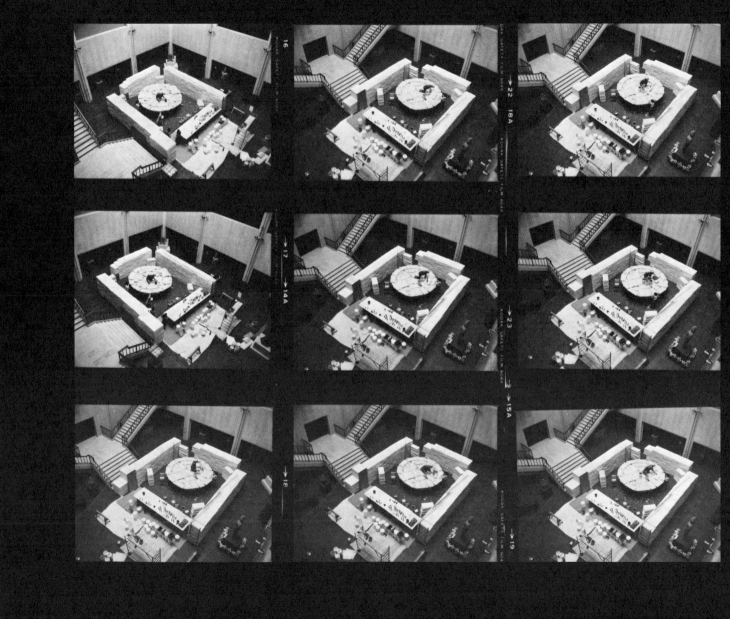

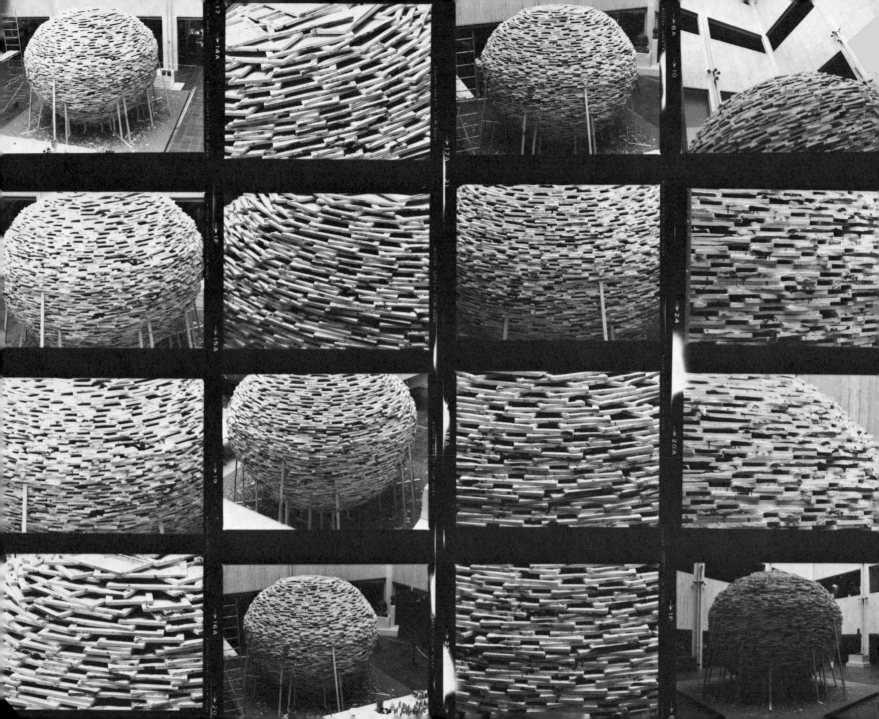

Michael C. **McMillen**

Born in Los Angeles, California, 1946;
lives in Santa Monica, California.

B.A., San Fernando Valley State College,
California, 1969; M.A., University of Califor-
nia, Los Angeles, 1972; M.F.A., 1973.

Central Meridian, 1981

Mixed-media environment
Ahmanson Gallery, third floor

Four of the artists who have chosen to work in-
doors have created environments or private worlds
within the Museum. Generally custom-built to the
artists' architectural specifications, these rooms of
Jonathan Borofsky, Chris Burden, Alexis Smith,
and Michael C. McMillen differ greatly from each
other. Installations of this type are normally tem-
poral and charged with the energy of working
intensely and directly in a given space and a specific
time frame.

s i t e

In McMillen's *Central Meridian* we experience the
analogy between a mid-twentieth-century Ameri-
can garage and cultural tomb. In the garage thirty
by sixteen feet that McMillen has had constructed
in the Museum, the viewer encounters, first
through the dusty, cracked window and then in per-
son, a 1964 Dodge Dart, resting on a bier-like plat-
form. McMillen sees a direct relation between this
work and aspects of ancient Egyptian or Chinese
culture. Surrounding the car, the garage is filled to
the point of bursting with relics, newspapers, and
detritus, all carefully selected and positioned. The
immediate impression is one of intruding into the
garage of a neighbor, perhaps of an eccentric, but
then quickly one begins to recognize familiar ob-
jects. Yet this environment is more than an engag-
ing recreation of a garage. As ancient tombs were
aimed at the afterlife, twentieth-century man, bred
in technology, saves and stores remnants of his own
culture. Entering McMillen's garage one has the
feeling of entering a modern tomb. The artist car-
ries his metaphor throughout; the chariot buried in
the tomb is now an American car of the sixties. The
icon—the car—is a centering element in the piece
which we, who live in an automotive city, instantly
recognize. While the ancients were buried with tab-
lets covered with writing depicting their family life,
our modern tomb is crammed with lawn mowers,
old radiators, bowling trophies, scientific laboratory
materials, a 1950s Sylvania "halo lite" television
set, old newspapers and magazines, phonographs—
all "stored" and buried in this dimly lit, musty
garage. Within the actual museum, McMillen has
transformed a gallery space into a veritable
museum of collectable objects—personal, evocative,
and mysterious.

McMillen sees his environment as a portrait of one
aspect of American culture after the Second World
War. He hopes the viewer will enter this timeless
garage as he would a tomb that has been sealed for
a long time. The detritus, castoffs, and found ob-
jects that fill the garage are cumulative clues which
help to evoke the personality of the owner. The per-
son whom this garage represents is complex—some-
one at home in a mini-laboratory, who gathers both
right-wing political and religious material, and sur-
rounds himself with relics of our technological era.

For several years McMillen's work has been evolv-
ing from small-scale environments toward more
complicated, full-scale tableaux. *Central Meridian*
is his first large-scale work in several years. Tab-
leaux have a special history in Los Angeles. In the
1960s Edward Kienholz executed a series of well-
known environments: *Roxys, The Beanery,* and
The Back Seat Dodge '38. McMillen's environment,
while lacking the biting social commentary of
Kienholz' pieces, is heir to those now historic tab-
leaux of the sixties.

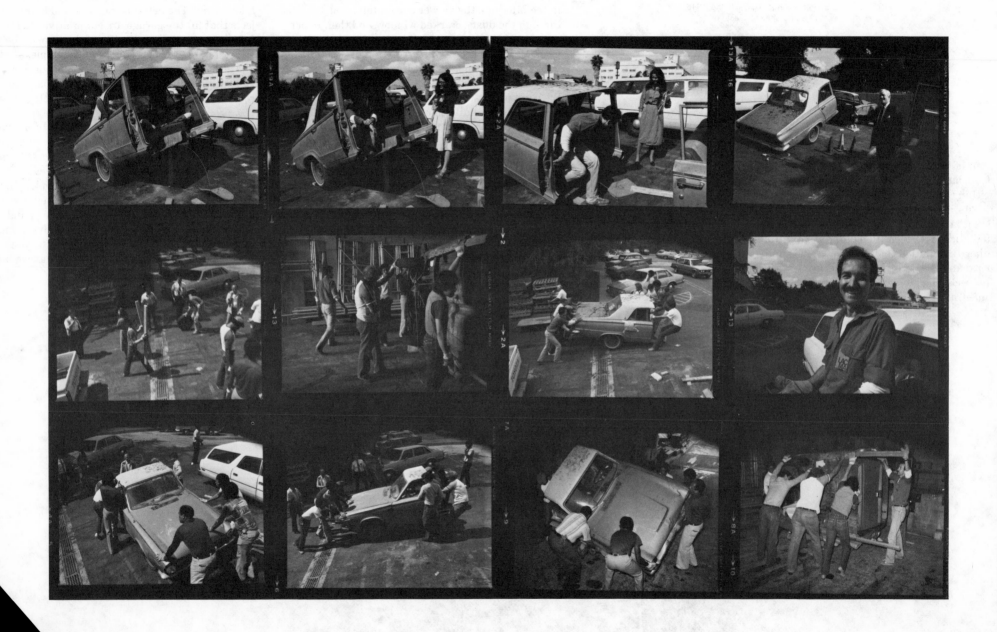

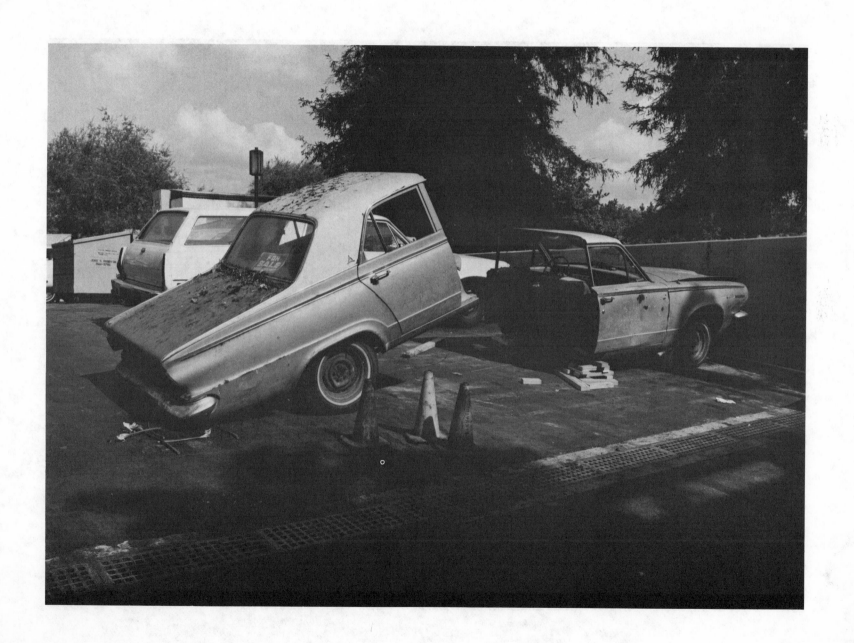

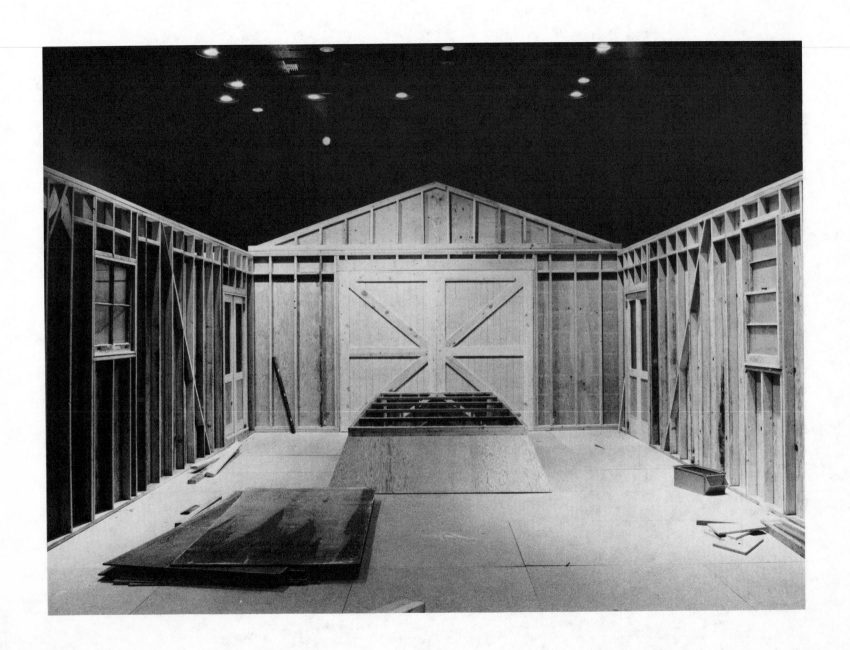

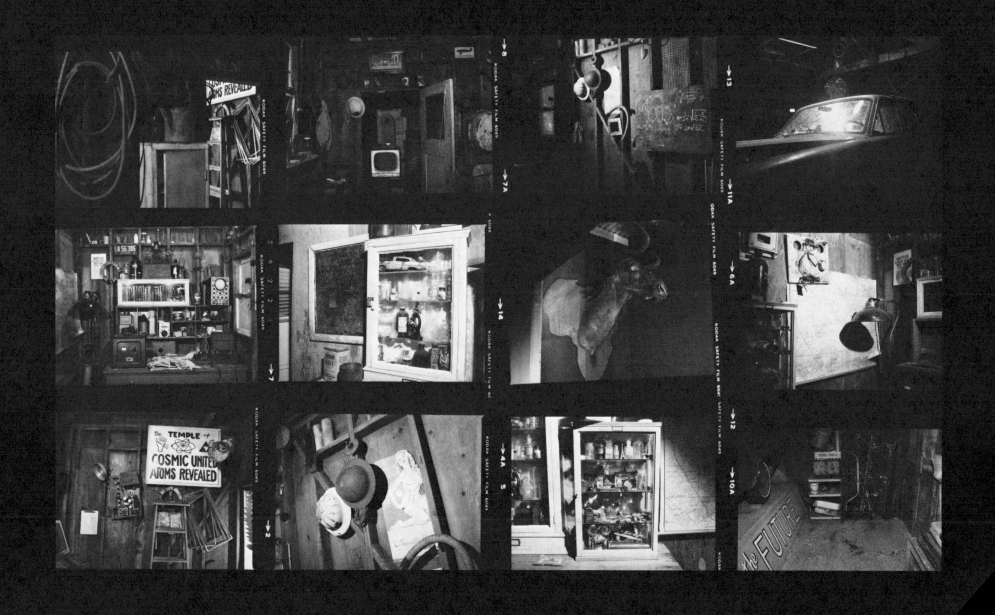

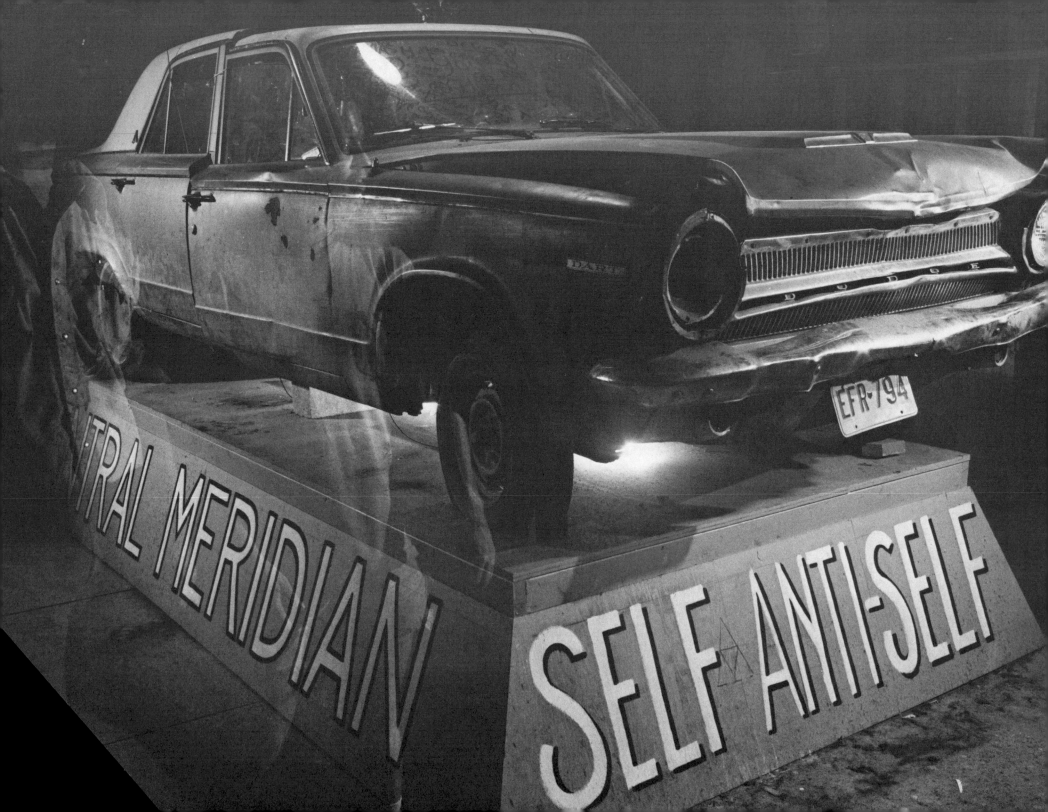

Jonathan **Borofsky**

Born in Boston, Massachusetts, 1942;
lives in Venice, California.

B.F.A., Carnegie-Mellon University,
Pittsburgh, Pennsylvania, 1964;
M.F.A., Yale School of Art and Architecture,
New Haven, Connecticut, 1966.

*I Dreamed a Dog Was Walking a Tightrope
at 2,715,346,* 1981

Mixed-media-and-video gallery installation
Ahmanson Gallery, third floor

Painter Jonathan Borofsky has created an environment, *I Dreamed a Dog Was Walking a Tightrope at 2,715,346,* consisting of words and multi-scaled images and objects that cover the floor, walls, and ceilings. Like the Surrealists, he draws his imagery from his dreams. Because Borofsky fills the room completely with a whorl-like covering, the viewer feels he has entered the mind of the artist. Borofsky covers his walls with his own iconographic vocabulary—the running man, a videotape with a dog who endlessly walks back and forth on a tightrope, a cutout large-scale automaton who hammers endlessly, a ping-pong table complete with paddles and balls inviting viewer participation, a ceiling-wall-floor bug-eyed, rabbit-eared character with a pulsating strobe light, and whirling, twirling rubies, fish, and other seemingly unrelated figures. The effect of these images, combined with political, social, and economic slogans, graffiti, and phrases scattered throughout the room, is both one of total disorientation and of being wholly within a space conceived of and "programmed" by the artist. Borofsky's piece attends three of our senses in an arresting way.

s i t e

Borofsky's painting method—working directly on the wall and filling the space in a *horror vacuii* manner—puts very little between the viewer and the psyche of the artist. His working method carries through his critical intentions. Armed with several boxes filled with over a hundred eight-by-ten-inch black-and-white drawings on acetate, Borofsky uses an opaque projector in an attempt to decide which images best fit particular sections of the room. As he selects an appropriate drawing he then paints or draws the image directly on the wall, filling in details free-hand. Occasionally, images will emerge during the development of the piece. In this installation, for example, Borofsky used a large ladder and scaffolding. While he was working, the scaffolding cast a particularly haunting shadow on the wall which he then incorporated into the finished work. Similarly, Borofsky's interaction with the staff and crew involved in his installation can also evolve into an image or phrase in the finished work; here the phrase, "The most powerful thing in the world is your mind. R. Lockhart," comes from a Museum painter assigned to work on this installation. The striking images and the unmistakable signs of process convey in a compelling and forceful way the energy of Borofsky's attitude toward art.

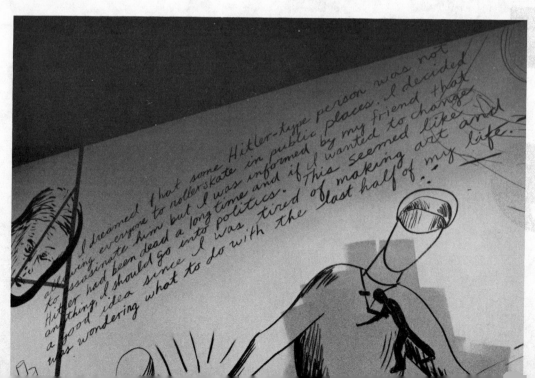

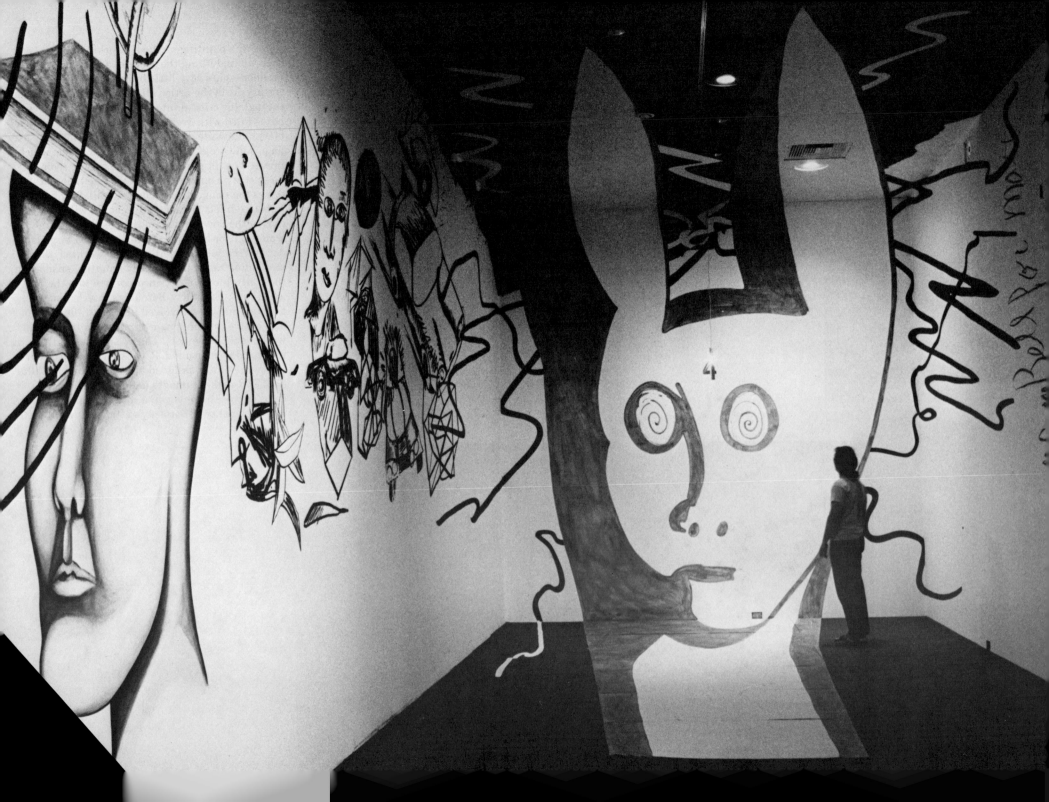

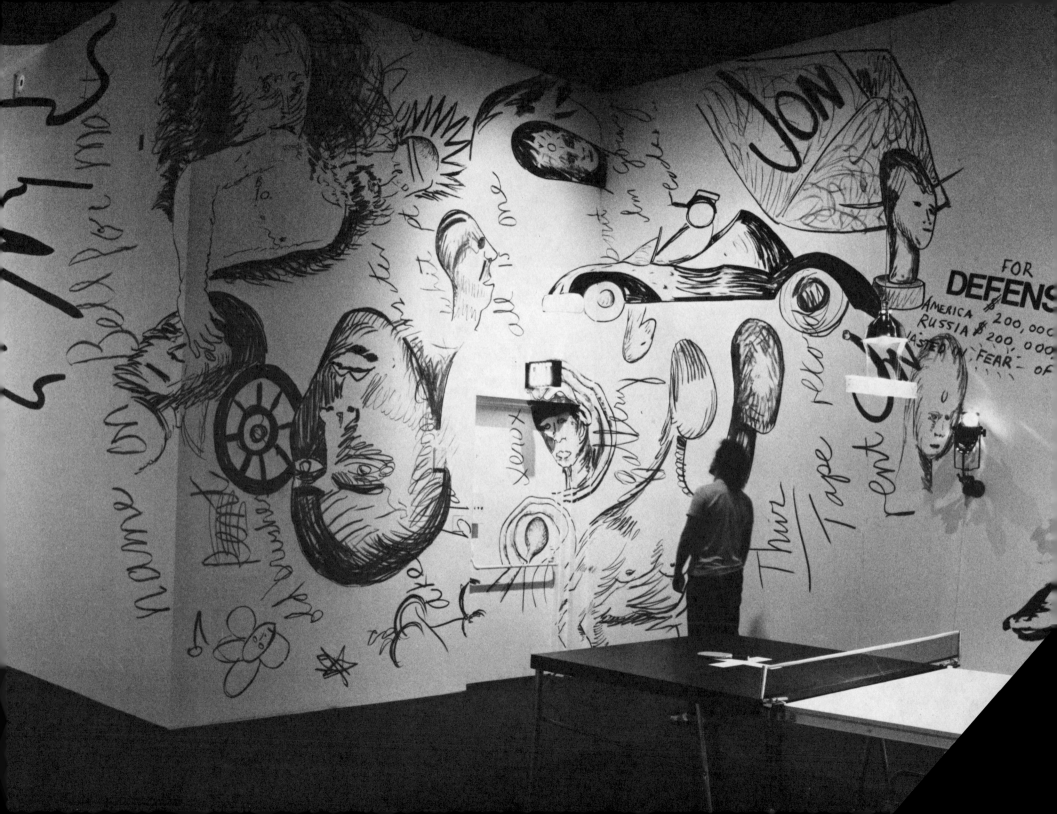

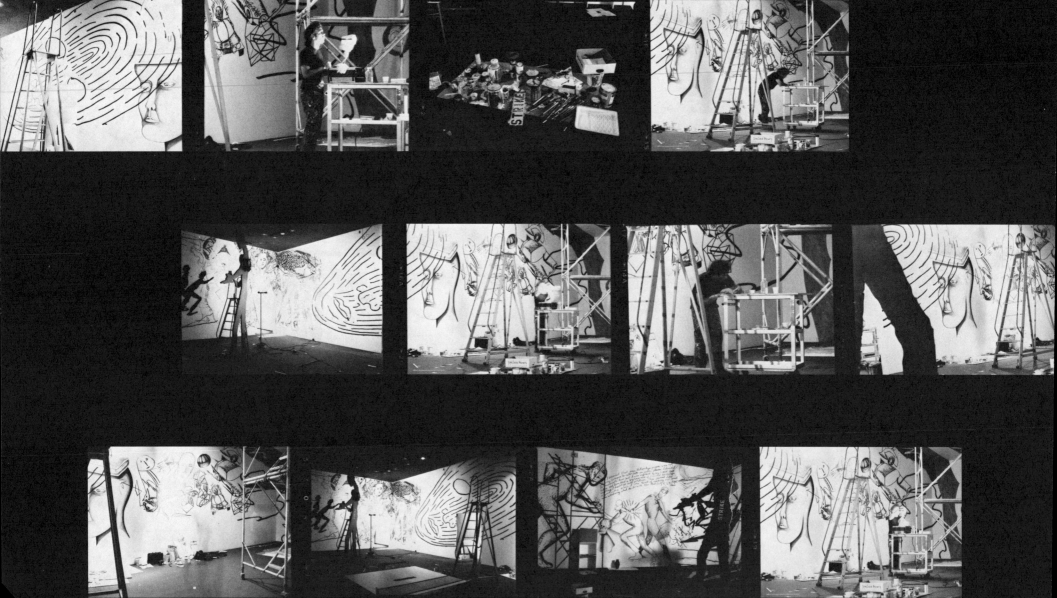

Alexis **Smith**

Born in Los Angeles, 1949;
lives in Venice, California.

B.A., University of California, Irvine, 1970.

Cathay, 1981

Mixed-media gallery installation
Ahmanson Gallery, third floor

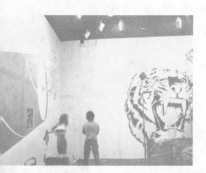

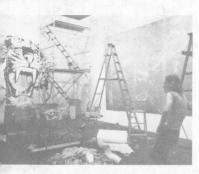

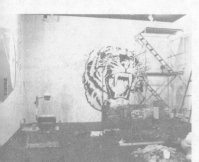

Alexis Smith's mixed-media environment *Cathay,* through a combination of words, images, and architecture, calls into question aspects of "old China" and "new China" cultures. In the past, Smith has executed multipartite narratives by linking together a series of eight-by-ten-inch sheets of paper with sequential lines from a particular literary work typed at the bottom, with suggestive or compatible collages on the same page. Thus, Raymond Chandler's Los Angeles, Thomas Mann's *Magic Mountain,,* "Sinbad," or George Gershwin's *Porgy and Bess* have become the subjects of her work. Confining her work at first to individual sheets, Smith progressed to series of several pages, then to entire walls, and finally, here, to four walls, floor, and ceiling. This installation is a breakthrough for Smith. Instead of texts which read sequentially around the room, Smith has intricately woven several "strands" of ancient Chinese philosophy, Charlie Chan, "Chinatown," contemporary Chinese politics, and oriental film culture into a richly textured series of collages that envelop the room. This non-linearity first appeared in a recent performance Smith created, *Stardust,* a recitation based on lines from several sources of American literature, song, and film.

Smith has had constructed a room with a portal and window inspired by ancient Chinese architecture. Circular and square holes have been cut in the surface to expose an understructure—a bright red, interlocking structure, giving the viewer the idea that this runs throughout the room. Inside, the walls have been painted a pale pink and the joints have been painted a pale green—an underpainting done as if it were a primer coat with the green "mud" left spotted across the walls. On top of this Smith has painted, on each of three walls, a large image—a bright red firecracker, a tiger's head, and a green chalkboard. As the final layer, Smith has affixed various collages, each with a typed phrase on the bottom edge of the paper. The groups of collages usually are punctuated by the addition of a China plate, which functions visually to divide the groupings of collages. Scattered around the floor in the four corners and hanging from the ceiling are everyday objects—a shopping cart, a broom, a rose, and an iron—each transformed by bright-colored paint. Smith's installation, her most ambitious to date, is about the layering of surfaces, literally, philosophically, and texturally, embodied within Chinese culture. Smith uses the visual objects in the room to interpret the text that she has created. The complexity and ambitiousness of this environment extends a finite narrative to the entire ambient field of the room. All of the "clues" which Smith employs *together* evoke the feeling of "China." It is a tour-de-force piece characterized by an immediacy of texture, color, and image.

s i t e

16

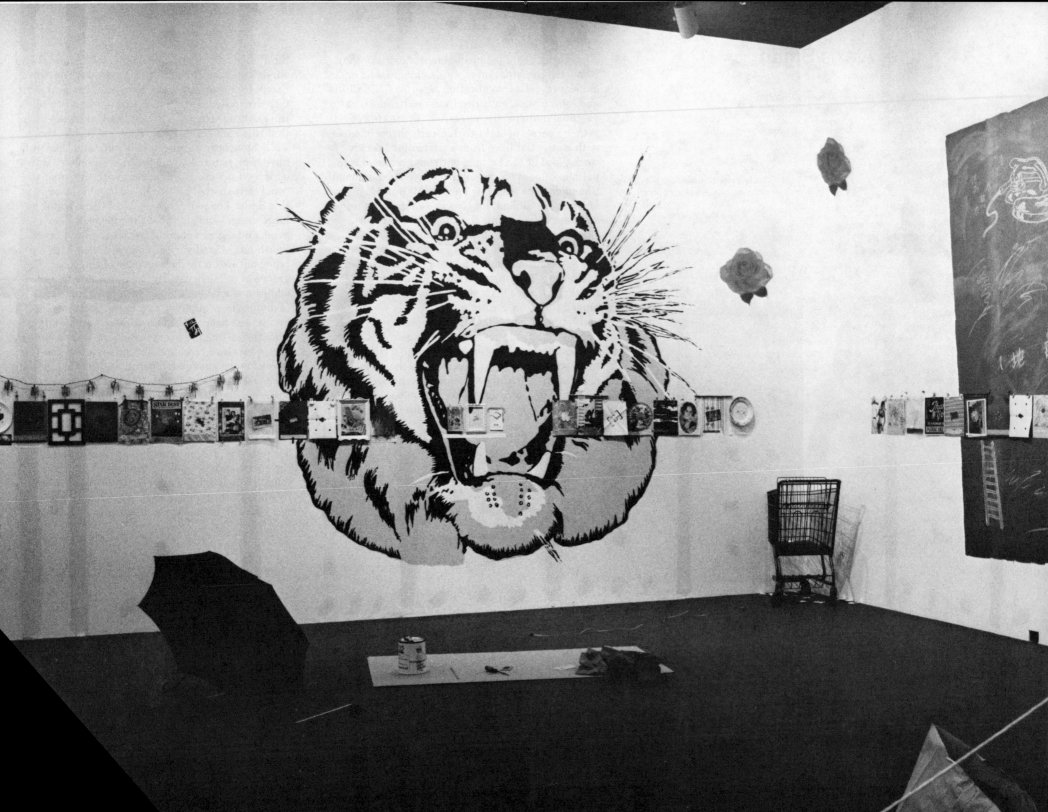

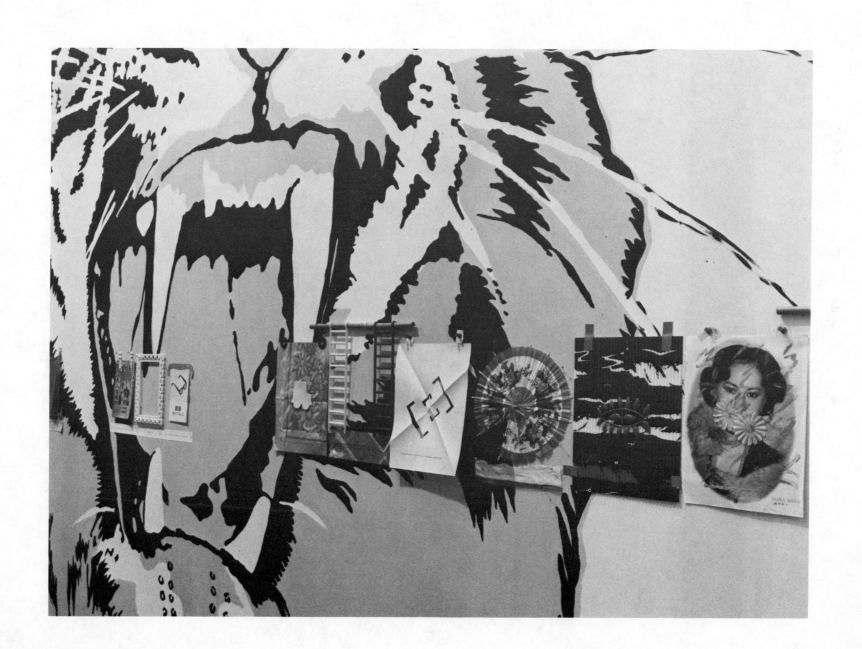

Chris **Burden**

Born in Boston, Massachusetts,
1946; lives in Los Angeles, California.

B.A., Pomona College, Claremont, California,
1969; M.F.A., University of California, Irvine, 1971.

A Tale of Two Cities, 1981

Mixed-media gallery installation
Ahmanson Gallery, third floor

site

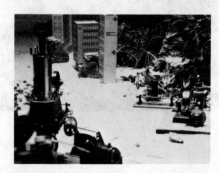

A Tale of Two Cities is a fantasy environment created by Chris Burden which uses hundreds of small toys. Burden's environment is made up of two miniature cities at war. Each city is nestled between six- to eight-inch formations and full-scale rich foliage, all set on a sand-filled desert landscape. Visually and texturally this is a beautiful and rich piece, but these qualities belie its sinister implications. Burden has been known nationally and internationally for some years for his provocative and often newsmaking performances that depend for their tension on the artist's relation to his audience. In one piece, *White Light/White Heat,* of 1975, created in a New York gallery, Burden constructed a corner shelf above the viewer's sight level. The viewer could walk into the otherwise empty gallery and *see* the shelf but not see all the way into the corner. The implication of the piece was that Burden was living in the gallery, on the shelf, for the duration of the exhibition. Gallery goers never were quite sure if Burden was there (observing them) or if the whole piece was a hoax. A mystery and tension emerged. Recently, Burden has been interested in exploring social systems (money, banking, and power) and aspects of international affairs and global warfare. Here, working within the confines of a Jungian room-size sand tray, Burden has assembled two warring cities in miniature.

Initially, the viewer is enchanted with the execution of a childlike fantasy of hundreds of toys in a sand box. But quickly a kind of tension sets in as the viewer cannot really see in detail what is going on since the tableau is on a sand base and the viewer is kept at arm's length. Details do emerge —the "city walls" are actually dozens of bullets standing on end; hundreds of small soldiers and tanks continue to literally emerge from the background. The only way the viewer can actually see the piece in detail is through the binoculars supplied by the artist. Again, that tension of the artist erecting an invisible barrier between himself and the audience emerges. The war games that Burden enacts transcend a particular time or place; the environment is filled with creatures from the ancient past, relics of our contemporary society, as well as inhabitants and weaponry of a futuristic society.

69

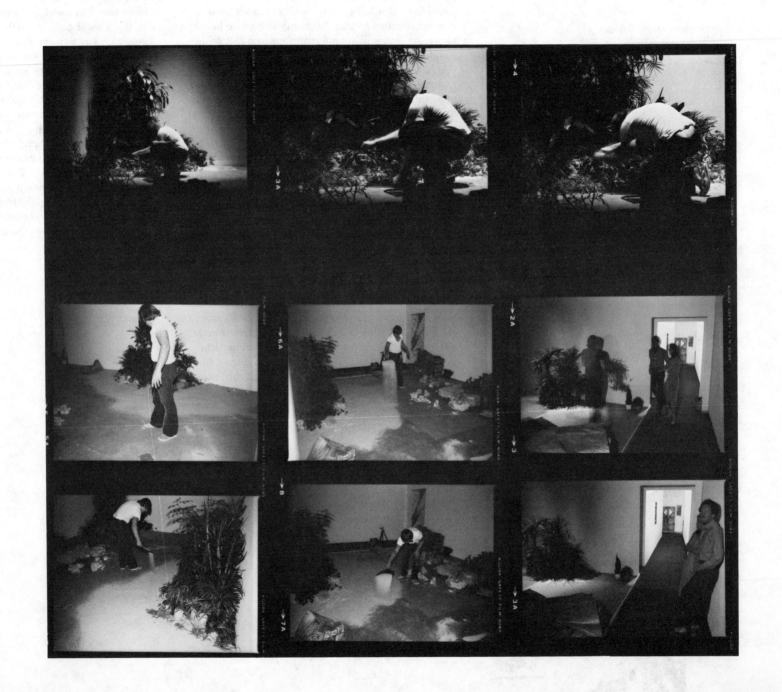

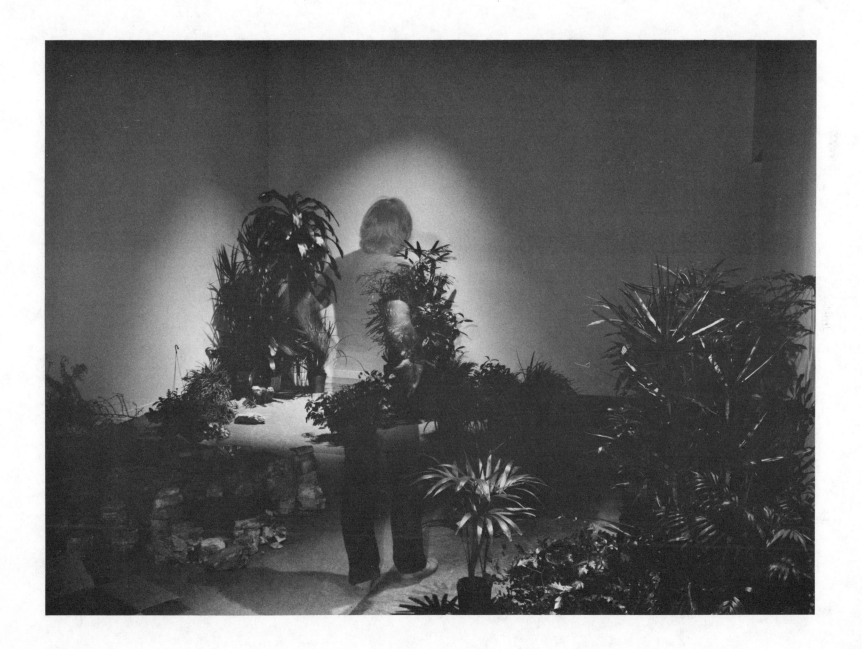

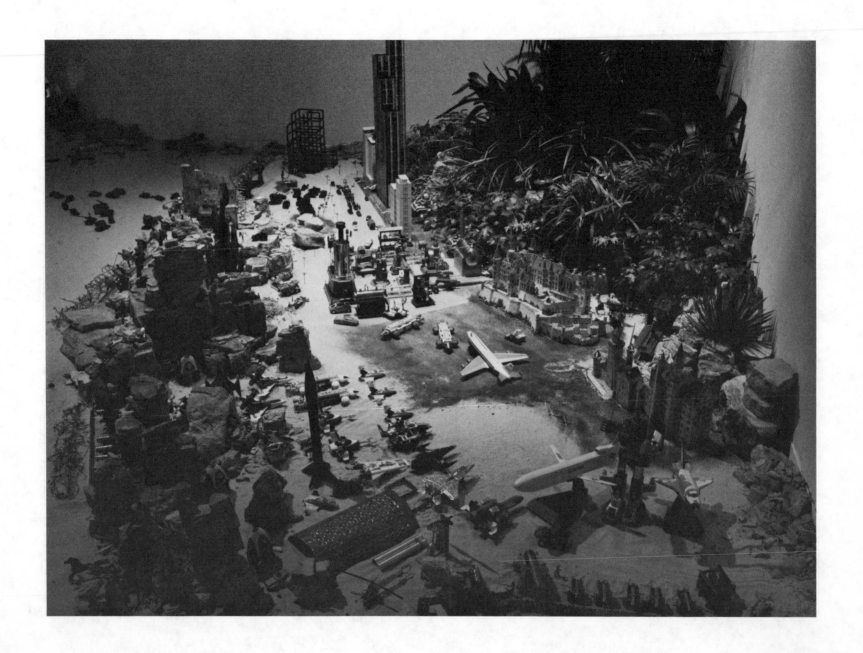

Eric **Orr**

Born in Covington, Kentucky, 1939;
lives in Venice, California.

Attended University of California, Berkeley;
University of Mexico; New School for
Social Research, New York; École de
Pataphysiques, Paris; and University of
Cincinnati, Ohio.

Prime Matter, 1981

Column of flame and fog
h: 20 ft.
Outdoors: Upper Plaza, in front of
Ahmanson Gallery

s i t e

Eric Orr's twenty-foot-high column of fog and flame,
Prime Matter, rises majestically in front of the
Ahmanson Gallery. Set on a six-foot-high pedestal,
this thin column has a constant line of flame rising
the length of its shaft; the flame then disappears
into a thick cloud of vapor. The force and direction
of the wind, of course, directly affect the sculpture,
which becomes omnipresent for the Museum
viewer. For many years, Orr has executed pieces
that deal with the elements and with phenomenol-
ogy. Air, fire, water, and the properties of certain
metals (e.g., gold) have become both subject and
material for his art. Orr is always concerned with
bringing these elements together in a way that is
extremely beautiful and often enigmatic or mysti-
cal. The interest of the ancients in these elements
and their properties is shared by Orr. This column
of fog and flame is ethereally beautiful and engag-
ing. Technologically, it is an ambitious endeavor, yet
fortunately the simplicity of the two elements
belies the sophistication of the systems necessary
to make it work within the public setting of the
Museum.

Positioned directly across the upper Museum Plaza
from Lloyd Hamrol's *Squaredance* and next to one
part of Irwin's installation, Orr's piece deals, too,
with its relationship to its site. While Hamrol has
emphasized the horizontal in his work, Irwin and
Orr both choose to reinforce the verticality and col-
umnation of the buildings' structure.

The cloud of steam emitted by Orr's column inevi-
tably touches the nearby viewer to create an
awesome, even spiritual, feeling not unlike that pro-
duced by a splendid natural wonder. That Orr
accomplishes this amidst the concrete and steel of
the Museum is all the more remarkable.

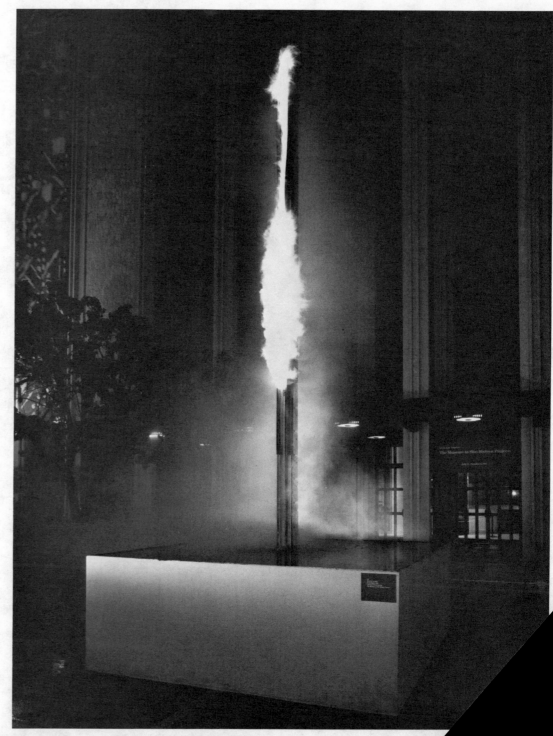

Photographer: Larry Reynolds

Michael **Asher**

Selected One-Person Exhibitions

1979 Corps de Garde, Groningen, the Netherlands. Museum of Contemporary Art, Chicago.

1977 Stedelijk van Abbemuseum, Eindhoven, the Netherlands.
Claire Copley Gallery Inc., Los Angeles and Morgan Thomas Gallery, Santa Monica, California.

1975 Otis Art Institute Gallery, Los Angeles.

1974 Claire S. Copley Gallery, Los Angeles.

1973 Heiner Friedrich, Cologne, West Germany. Galleria Toselli, Milan, Italy.

1969 La Jolla Museum of Art, California.

Selected Group Exhibitions

1981 *Westkunst*, Cologne, West Germany.

1979 *73 American Exhibition*, The Art Institute of Chicago.

1977 *Los Angeles in the Seventies*, Fort Worth Art Museum, Texas, (traveled to Joslyn Art Museum, Omaha, Nebraska).
Faculty Exhibition, California Institute of the Arts, Valencia.
Skulptur, Westfalisches Landesmuseum für Kunst und Kulturgeschichte, Münster, West Germany.
Michael Asher, David Askevold, Richard Long, Los Angeles Institute of Contemporary Art.

1976 *Ambiente*, Venice Biennale, Italy.
Painting and Sculpture in California: The Modern Era, San Francisco Museum of Modern Art, (traveled to National Collection of Fine Arts, Smithsonian Institution, Washington, D.C.).
Via Los Angeles, Portland Center for the Visual Arts, Oregon.

1975 *University of California, Irvine, 1965–75*, La Jolla Museum of Contemporary Art, California.

1972 *Documenta 5*, Kassel, West Germany.

1971 *24 Young Los Angeles Artists*, Los Angeles County Museum of Art.

1969 *Spaces*, The Museum of Modern Art, New York.
Anti-Illusion: Procedures/Materials, Whitney Museum of American Art, New York.

John **Baldessari**

Selected One-Person Exhibitions

1981 The New Museum, New York.

1980 Folkwang Museum, Essen, West Germany. Sonnabend Gallery, New York (Also in 1978, 1975, and 1973).

1979 *New Work, Installation with Photographs*, Ink, Halle für internationale Neue Kunst, Zurich, Switzerland.

1978 Portland Center for the Visual Arts, Oregon
Baldessari: New Films, Whitney Museum of American Art, New York.

1977 Julian Pretto Gallery, New York
Matrix, Wadsworth Atheneum, Hartford, Connecticut.

1976 James Corcoran Gallery, Los Angeles. Cirrus Gallery, Los Angeles.
Ohio State University, Columbus.
Ewing and George Paton Galleries, Melbourne, Australia.

1975 University of California, Irvine.
The Kitchen, New York.
Stedelijk Museum, Gemeentemusea, Amsterdam, the Netherlands.

1973 Konrad Fischer Gallery, Düsseldorf, West Germany (Also in 1971).

1972 Jack Wendler Gallery, London. Galleria Toselli, Milan, Italy.

1971 Nova Scotia College of Art and Design, Halifax.
Art and Project, Amsterdam, the Netherlands.

1970 Eugenia Butler Gallery, Los Angeles. Richard Feigen Gallery, New York.

1968 Molly Barnes Gallery, Los Angeles.

1962 Southwestern College, Chula Vista, California.

1960 La Jolla Museum of Art, California.

Selected Group Exhibitions

1981 *Westkunst*, Cologne, West Germany.

1980 *The Photograph Transformed*, Touchstone Gallery, New York.
Pier and Ocean, Arts Council of Great Britain, London.
Contemporary Art in Southern California, The High Museum of Art, Atlanta, Georgia.

1979 *Attitudes*, Santa Barbara Museum of Art, California.
Words, Museum Bochum-Kunstsammlung, West Germany.
Concept, Narrative, Document, Museum of Contemporary Art, Chicago, (traveled to Los Angeles County Museum of Art).

1978 *Artworks and Bookworks*, Los Angeles Institute of Contemporary Art.
Art about Art, Whitney Museum of American Art, New York.
Narration, Institute of Contemporary Art, Boston.

1976 *Painting and Sculpture in California: The Modern Era*, San Francisco Museum of Modern Art, (traveled to National Collection of Fine Arts, Smithsonian Institution, Washington, D.C.).
Rooms, P.S.1, The Institute for Art and Urban Resources, Long Island City, New York.

1974 *Projekt '74*, Cologne, West Germany.

1973 *Southern California Attitudes*, Pasadena Museum of Modern Art, California.

1972 *Documenta 5*, Kassel, West Germany.
Whitney Biennial, Whitney Museum of American Art, New York (Also *Whitney Biennial*, 1969).

1970 *Information*, The Museum of Modern Art, New York.
Software, The Jewish Museum, New York.

1969 *Pop Art Redefined*, Hayward Gallery, London.
Language III, Dwan Gallery, New York.

Jonathan **Borofsky**

Selected One-Person Exhibitions

1981 The Contemporary Arts Museum, Houston, Texas.

1980 Paula Cooper Gallery, New York (Also in 1979, 1976, and 1975).

1979 Ink, Halle für internationale Neue Kunst, Zurich, Switzerland.

1978 Corps de Garde, Groningen, the Netherlands.
University Art Museum, University of California, Berkeley.

1976 Wadsworth Atheneum, Hartford, Connecticut.

Selected Group Exhibitions

1981 *Twenty Artists*, Yale University Art Gallery, New Haven, Connecticut.
Westkunst, Cologne, West Germany.
Whitney Biennial, Whitney Museum of American Art, New York.

1980 *Visions and Figurations*, Art Gallery, California State University, Fullerton.
Dame il tempo di guardare, Padiglione d'Arte Contemporanea, Milan, Italy.
Drawings: The Pluralist Decade, American Pavilion, Venice Biennale, Italy.

1979 *Sixth Anniversary Exhibition*, Artists Space, New York.
Tendencies in American Drawing of the Late Seventies, Stadtische Galerie im Lenbachhaus, Munich, West Germany.
Born in Boston, De Cordova and Dana Museum, Lincoln, Massachusetts.
Ten Artists/Artists Space, Neuberger Museum, State University of New York, Purchase.

1978 *Minimal Image*, Protech-McIntosh Gallery, Washington, D.C.

1977 *Surrogates/Self-Portraits*, Holly Solomon Gallery, New York.
Critics' Choice, Lowe Art Gallery, Syracuse University, New York.

1976 *Soho*, Akademie der Kunste, Berlin, West Germany. (traveled to Louisiana Museum, Humlebaek, Denmark).
International Tendencies '72–'76, Venice Biennale, Italy.

1975 *Lives*, Fine Arts Building, New York.

1974 *Drawing and Other Work*, Paula Cooper Gallery, New York.

1973 Artists Space, New York.

1970 *557,087*, Seattle Art Museum, Washington (traveled to Vancouver Art Gallery, British Columbia, Canada).

1969 *No. 7*, Paula Cooper Gallery, New York.

1966 Wadsworth Atheneum, Hartford, Connecticut.

Michael **Brewster**

Selected One-Person Exhibitions

1980 *Slow Step/Side Shuffle,* Tyler School of Art, Philadelphia, Pennsylvania.
The Air in the Skyway, Minneapolis College of Art and Design Gallery, Minnesota.

1979 *Clue Blear,* Art Gallery, California State University, Long Beach.
Floating in Coincidence, Four Phasing, and *Pulsing Overlap,* Galleria del Cavallino, Venice, Italy.
Stop Gap, Modern Art Gallerie, Vienna, Austria.
Hit and Run, Lauwersmeer Bij Oostmahorn, Friesland (produced by Corps de Garde, Groningen, the Netherlands).
Surrounded: Sharp Point Ringing, Cirrus Gallery, Los Angeles.

1978 *Concrete Two Tone,* Marum Overpass-Kw IX A (produced by Corps de Garde, Groningen, the Netherlands).

1977 *Synchromesh,* Meyer Gallery, La Jolla Museum of Contemporary Art, California.
Inside, Outside, Down and Soliloquies, Baxter Art Gallery, California Institute of Technology, Pasadena, California.
An Acoustic Sculpture and a Clicker Drawing, Artists Space, New York.

1976 *The Field Contained by Room 094,* University of Victoria, British Columbia, Canada.

1971 *Standing Wave,* Space F, Santa Ana, California (Also *Fixed Frequency* and *Number 013*).

1970 *Configuration 010,* Montgomery Art Gallery, Pomona College, Claremont, California.

Selected Group Exhibitions

1981 *Whitney Biennial,* Whitney Museum of American Art, New York.

1979 *Sound at P.S.1,* The Institute for Art and Urban Resources, Long Island City, New York.
Sound, Los Angeles Institute of Contemporary Art.

1977 *Los Angeles in the Seventies,* Fort Worth Art Museum, Texas (traveled to Joslyn Art Museum, Omaha, Nebraska).

1976 *Sounds,* Newport Harbor Art Museum, Newport Beach, California (Also *New Art in Orange County,* 1972).

Chris **Burden**

Selected Performances

1978 *In Venice Money Grows on Trees,* California.
C.B.T.V. to Einstein, Air France SST Concorde Flight between Paris and Washington, D.C.

1977 *C.B.T.V.,* Documenta 6, Kassel, West Germany (Also at Ronald Feldman Fine Arts New York, 1977).

1976 *Shadow,* Ohio State University, Columbus.
Do You Believe in Television?, Alberta College of Art, Calgary, Canada.
Natural Habitat (with Alexis Smith), Portland Center for the Visual Arts, Oregon.

1975 *Yankee Ingenuity,* Stadler Gallery, Paris.
Art and Technology, De Appel, Amsterdam, the Netherlands.
Oracle, Schema Gallery, Florence, Italy.
La Chiaraficazione, Galleria Alessandra Castelli, Milan, Italy.
Doomed, Museum of Contemporary Art, Chicago.
White Light/White Heat, Ronald Feldman Fine Arts, New York.

1974 *The Visitation,* Hamilton College, New York.
Velvet Water, School of the Art Institute of Chicago.
Trans-Fixed, Venice, California.
Back to You, 112 Greene Street, New York.

1973 *Through the Night Softly,* Main Street, Los Angeles.
Fire Roll, Museum of Conceptual Art, San Francisco (Also *I Became a Secret Hippy,* 1971).

1972 *Deadman,* Riko Mizuno Gallery, Los Angeles.
Jaizu, Newport Harbor Art Museum, Newport Beach, California.

1971 *Shoot,* Space F, Santa Ana, California (Also *220,* 1971; *Prelude to 220, or 110,* 1971; *Shout Piece,* 1971)
Five Day Locker Piece, University of California, Irvine (Also *Bicycle Piece,* 1971).

Selected Exhibitions/Installations

1980 *Chris Burden—C.B.T.V. and The B-Car,* Whitney Museum of American Art, New York.
Southern California Drawings, Joseloff Gallery, Hartford Art School, University of Hartford, Connecticut.
The Big Wheel, Devil Drawings, and *Sculptures,* Ronald Feldman Fine Arts, New York (Also at Rosamund Felsen Gallery, Los Angeles, 1979).
First Person Singular: Recent Self-Portraiture, Pratt Institute, Brooklyn, New York.

1979 *Video Artists, Books, and Guest Performers,* Kansas City Art Institute, Missouri.
Born in Boston, De Cordova and Dana Museum, Lincoln, Massachusetts.
The Reason for the Neutron Bomb, Ronald Feldman Fine Arts, New York (Also *C.B.T.V.,* 1977; *The B-Car,* 1977; and in 1975, 1974).

1975 *Bodyworks,* The Museum of Contemporary Art, Chicago.
Projects Video, The Museum of Modern Art, New York.
Galerie Stadler, Paris (Also in *L'Art Corporel,* 1974).
De Appel, Amsterdam, the Netherlands.
Galleria Schema, Florence, Italy.
Galleria Alessandra Castelli, Milan, Italy.
Riko Mizuno Gallery, Los Angeles (Also in 1974).

Karen **Carson**

Selected One-Person Exhibitions

1980 Rosamund Felsen Gallery, Los Angeles (Also in 1979).

1977 Cirrus Gallery, Los Angeles (Also in 1976 and 1973).

Selected Group Exhibitions

1981 *Decade: Los Angeles Painting in the Seventies,* Art Center College of Design, Pasadena, California.
Abstractions, San Francisco Art Institute.

1979 *L.A. Drawing Show,* University of New Mexico Art Gallery, Albuquerque.

1978 *L.A. Women Narrations,* Mandeville Art Gallery, University of California, San Diego.
A Point of View, Los Angeles Institute of Contemporary Art.

1977 *Current Concerns,* Fine Arts Gallery, University of Iowa, Iowa City.

1976 *Contemporary Masters,* Libra Gallery, Claremont Graduate School, California.

1975 *Drawings,* Newport Harbor Art Museum, Newport Beach, California.

1972 *California Women Painters,* Lang Art Gallery, Scripps College, Claremont, California.
The Wall Object, La Jolla Museum of Contemporary Art, California.
15 Los Angeles Artists, Pasadena Art Museum, California.

Robert **Graham**

Selected One-Person Exhibitions

1981 Walker Art Center, Minneapolis, Minnesota.
Gallery Six, Robert Graham: Five Statues, Los Angeles County Museum of Art (Also in 1978).

1980 Dorothy Rosenthal Gallery, Chicago (Also in 1978 and 1975).

1979 Dag Hammarskjöld Plaza, New York.
Galerie Neuendorf, Hamburg and Cologne, West Germany (Also in 1976, 1974, 1970, and 1968).
Robert Miller Gallery, New York (Also in 1978).

1977 Nicholas Wilder Gallery, Los Angeles (Also in 1975, 1974, 1969, 1967, and 1966).

1975 Gimpel & Hanover Galerie, Zurich, Switzerland (Also in Basel, Switzerland, and in Zurich, 1974).
Felicity Samuel Gallery, London (Also in 1974).

1974 Texas Gallery, Houston.

1971 Kunstverein Hamburg, West Germany.
Sonnabend Gallery, New York.

1970 Whitechapel Art Gallery, London.

1969 Kornblee Gallery, New York (Also in 1968).

1964 Lanyon Gallery, Palo Alto, California.

Selected Group Exhibitions

1980 *Aspects of the 70's: Directions in Realism,* Danforth Museum, Farmington, Massachusetts.

1979 *Whitney Biennial,* Whitney Museum of American Art, New York (Also in 1971, 1969, and 1966).

1976 *Painting and Sculpture in California: The Modern Era,* San Francisco Museum of Modern Art, California (traveled to National Collection of Fine Arts, Smithsonian Institution, Washington, D.C.).
L.A.8: Painting and Sculpture '76, Los Angeles County Museum of Art.

1975 Sculpture: American Directions, 1945–1975, National Collection of Fine Arts, Smithsonian Institution, Washington, D.C.

1974 71st American Exhibition, Chicago Art Institute.

1972 USA West Coast, Kunstverein Hamburg, West Germany (Also traveled to Kunstverein Hannover; Kölnischer Kunstverein, Cologne; Württembergischer Kunstverein, Stuttgart).

1971 Three Americans, Victoria and Albert Museum, London.

Lloyd **Hamrol**

Selected One-Person Exhibitions

1970 Installation, California State University, Fullerton.

1969 Installation, Pomona College, California.

1968 Installation, La Jolla Museum of Art, California.

Selected Group Exhibitions

1980 Across the Nation: Fine Art for Federal Buildings, 1972–79, National Collection of Fine Arts, Smithsonian Institution, Washington, D.C. (traveled to Hunter Museum of Art, Chattanooga, Tennessee).
Architectural Sculpture, Los Angeles Institute of Contemporary Art.
Sculpture in California, 1975–80, San Diego Museum of Art.
XI International Sculpture Conference, Washington, D.C.
Urban Encounters/Art Architecture Audience, Institute of Contemporary Art, University of Pennsylvania, Philadelphia.

1977 Los Angeles in the Seventies, Fort Worth Art Museum, Texas (traveled to Joslyn Art Museum, Omaha, Nebraska).

1976 Painting and Sculpture in California: The Modern Era, San Francisco Museum of Modern Art (traveled to National Collection of Fine Arts, Smithsonian Institution, Washington, D.C.).
Artpark, Lewiston, New York.

1975 Three L.A. Sculptors, Los Angeles Institute of Contemporary Art.
Site Sculpture, Zabriskie Gallery, New York.

1974 Public Sculpture/Urban Environment, Oakland Museum, California.

1973 Four Los Angeles Sculptors, Museum of Contemporary Art, Chicago.

1972 15 Los Angeles Artists, Pasadena Art Museum, California.

1971 Allen Bertoldi and Lloyd Hamrol, California State University, Fresno.

1970 String and Rope, Sidney Janis Gallery, New York.

1968 West Coast Now, Portland Museum of Art, Oregon (traveled to Seattle Museum of Art, Washington; San Francisco Museum of Modern Art; and Los Angeles Municipal Art Gallery).

1967 American Sculpture of the Sixties, Los Angeles County Museum of Art (traveled to Philadelphia Museum of Art, Pennsylvania).

1966 Annual Exhibition: Sculpture and Prints, Whitney Museum of American Art, New York.

Robert **Irwin**

Selected One-Person Exhibitions

1977 Whitney Museum of American Art, New York.

1976 Walker Art Center, Minneapolis, Minnesota.
Riko Mizuno Gallery, Los Angeles (Also in 1974 and 1972).

1975 Fort Worth Art Museum, Texas.
Museum of Contemporary Art, Chicago.

1974 Pace Gallery, New York (Also in 1973, 1971, 1969, 1968, and 1966).

1971 The Museum of Modern Art, New York.
Ace Gallery, Los Angeles.

1968 Pasadena Art Museum, California (Also in 1960).

1964 Ferus Gallery, Los Angeles (Also in 1962, 1960, and 1959).

Selected Group Exhibitions

1980 Contemporary Art in Southern California, The High Museum of Art, Atlanta, Georgia.

1979 Andre, Buren, Irwin, Nordman: Space as Support, University Art Museum, University of California, Berkeley.

1976 Painting and Sculpture in California: The Modern Era, San Francisco Museum of Modern Art (traveled to National Collection of Fine Arts, Smithsonian Institution, Washington, D.C.).
The Last Time I Saw Ferus 1957–1966, Newport Harbor Art Museum, Newport Beach, California.

Projects for PCA, Philadelphia College of Art, Pennsylvania.
Venice Biennale, Italy.
200 Years of American Sculpture, Whitney Museum of American Art, New York.

1974 Some Recent American Art, The Museum of Modern Art, New York.

1973 Works in Spaces, San Francisco Museum of Modern Art.

1972 USA West Coast, Kunstverein Hamburg, West Germany (traveled to Kunstverein Hannover; Kölnischer Kunstverein, Cologne; and Württembergisher Kunstverein, Stuttgart).

1971 11 Los Angeles Artists, Hayward Gallery, London (traveled to Musées Royaux de Beaux-Arts, Brussels; Akademie der Kunste, Berlin, West Germany).
Art and Technology, Los Angeles County Museum of Art.

1970 Permutations: Light and Color, Museum of Contemporary Art, Chicago.
Bell/Irwin/Wheeler, The Tate Gallery, London.

1969 Kompas 4: West Coast USA, Stedelijk van Abbemuseum, Eindhoven, the Netherlands (traveled to Pasadena Art Museum, California; City Art Museum of St. Louis, Missouri; Art Gallery of Ontario, Toronto; Fort Worth Art Center Museum, Texas).

1968 Late Fifties at the Ferus, Los Angeles County Museum of Art.
Documenta 4, Kassel, West Germany.
6 Artists, 6 Exhibitions, Walker Art Center, Minneapolis, Minnesota.

1966 Robert Irwin/Kenneth Price, Los Angeles County Museum of Art.

1965 VIII Bienal de São Paulo, Brazil.
The Responsive Eye, The Museum of Modern Art, New York (traveled to Pasadena Art Museum).

1962 Fifty California Artists, Whitney Museum of American Art, New York.

Richard **Jackson**

Selected One-Person Exhibitions

1980 Rosamund Felsen Gallery, Los Angeles (Also in 1978).
Galerie Maeght, Paris (Also in Zurich, Switzerland, 1979).
Forum Kunst, Rottweil, West Germany.

1979 D.A.A.D. Gallery, Berlin, West Germany.

1977 Fine Arts Gallery, University of California, Irvine.

1976 Riko Mizuno Gallery, Los Angeles (Also in 1974).
University of California, Davis.

1974 Bykert Gallery, New York.

1973 74 Gallery Onnasch, Cologne, West Germany.

1970 Eugenia Butler Gallery, Los Angeles (Also in 1969).

1968 Gallery 669, Los Angeles.

Selected Group Exhibitions

1979 Wall Painting, Museum of Contemporary Art, Chicago.

1978 Art about Art, Whitney Museum of American Art, New York.

1977 Rooms P.S.1, The Institute for Art and Urban Resources, Long Island City, New York.

1976 Painting and Sculpture in California: The Modern Era, San Francisco Museum of Modern Art (traveled to National Collection of Fine Arts, Smithsonian Institution, Washington, D.C.).

1975 Current Concerns, Part I, Los Angeles Institute of Contemporary Art.
Both Kinds: Contemporary Art from Los Angeles, University Art Museum, University of California, Berkeley.

1974 Fundamental Painting, Stedelijk Museum, Gemeentemusea, Amsterdam, the Netherlands.
Margo Leavin Gallery, Los Angeles.

1972 Los Angeles '72, Sidney Janis Gallery, New York.
John Baldessari/Francis Barth/Richard Jackson/Barbara Munger/Gary Stephan, Contemporary Arts Museum, Houston, Texas.
15 Los Angeles Artists, Pasadena Art Museum, California.

Richard Jackson

1971 *The 32nd Biennial Exhibition of Contemporary American Art,* Corcoran Gallery of Art, Washington, D.C.
24 Young Los Angeles Artists, Los Angeles County Museum of Art.

1970 *Photography into Sculpture,* The Museum of Modern Art, New York.

Jay McCafferty

Selected One-Person Exhibitions

1980 Baudoin Lebon Gallery, Paris.
Cirrus Gallery, Los Angeles (Also in 1979, 1977, and 1975).
Grapestake Gallery, San Francisco (Also in 1978 and 1976).

1976 Galerie Krebs, Bern, Switzerland.

1974 Newspace Gallery, Los Angeles.
Long Beach Museum of Art, California.

1973 Fine Art Gallery, University of California, Irvine.

1971 Purcell Gallery, Chapman College, Orange, California.

Selected Group Exhibitions

1976 *New Selections/New Talent Award Winners,* Los Angeles County Museum of Art.
Basel Art Fair, Switzerland.
Bologna Art Fair, Italy.

1975 *University of California, Irvine, 1965–1975,* La Jolla Museum of Contemporary Art, California.
Southland Video Anthology Traveling Show, Long Beach Museum of Art, California.
DeLap-McCafferty, Baxter Art Gallery, California Institute of Technology, Pasadena, California.

1973 *Festival of Contemporary Arts,* Allen Art Museum, Oberlin College, Ohio.

1971 *Fiber as Line,* California State College, Los Angeles (Also *Small Images Exhibition*).

Michael C. McMillen

Selected One-Person Exhibitions

1981 *The Floating Diner,* Pittsburgh Center for the Arts, Pennsylvania.

1980 Asher/Faure Gallery, Los Angeles.
Project 29: Michael McMillen, Art Gallery of New South Wales, Sydney, Australia.

1977 *Inner City,* Los Angeles County Museum of Art (traveled to Whitney Museum of American Art, New York, 1978).

1973 *The Traveling Mystery Museum,* Venice, California.

Selected Group Exhibitions

1980 *Architectural Sculpture,* Mount St. Mary's College Fine Arts Gallery, Los Angeles (produced by Los Angeles Institute of Contemporary Art).
Sculpture in Southern California 1975–80, San Diego Art Museum, California.
In a Major and Minor Scale, Los Angeles Municipal Art Gallery (Also *The Artist As Social Critic—1979;* and *Other Things That Artists Make,* 1978).
Tableau, Los Angeles Institute of Contemporary Art (Also in *Art Words and Bookworks,* 1978; *100+ Current Directions in Southern California Art,* 1978; *Imagination,* 1976; and *Collage and Assemblage,* 1975).

1979 *Eight Artists: The Elusive Image,* Walker Art Center, Minneapolis, Minnesota.

1978 *Artists Books—Bookworks,* Ewing and George Paton Galleries, Melbourne, Australia (traveled to Institute of Modern Art, Brisbane; Queen Victoria Museum and Art Gallery, Launceston; Experimental Art Foundation, Adelaide; Undercroft Gallery, Perth; and Geelong Art Gallery, The Sculpture Center, Sydney).
Eccentric Los Angeles Art, Arco Center for the Visual Arts, Los Angeles.
A Proposal for a Children's Museum, Baxter Art Gallery, California Institute of Technology, Pasadena (Also in two-person show, 1975).
Beyond Realism, Otis Art Institute, Los Angeles.

1977 *Miniature,* California State University, Los Angeles.
Los Angeles in the Seventies, Fort Worth Art Museum, Texas (traveled to Joslyn Art Museum, Omaha, Nebraska, 1979).

1975 *Sounds: Audio-Visual Environments by Four L.A. Artists,* Newport Harbor Art Museum, Newport Beach, California.
Eight Artists from Los Angeles, San Francisco Art Institute.
Crucifixes, Betty Gold/ Fine Modern Prints, Los Angeles.

1974 *First Annual California Sculpture Exhibition,* California State University, Northridge.

Eric Orr

Selected One-Person Exhibitions

1981 Neil G. Ovsey Gallery, Los Angeles.

1980 *Silence and the Ion Wind,* Los Angeles County Museum of Art.
Infinite Gold Void, Los Angeles Institute of Contemporary Art.

1979 *Chemical Light,* Janus Gallery, Los Angeles.

1978 *Drawings for the Gold Room,* Cirrus Gallery, Los Angeles (Also *Sunrise,* 1976, and in 1974).
Seasons of the Fountain, Larry Bell/Eric Orr, Delahunty Gallery, Dallas, Texas (traveled to Marion Goodman Gallery, New York).

1975 Salvatore Ala Gallery, Milan, Italy.

1973 University of California, Irvine.

1968 Eugenia Butler Gallery, Los Angeles.

Selected Group Exhibitions

1981 *Light and Space,* Lonny Gans and Associates, Venice, California.

1980 *Nothing Special,* P.S.1, The Institute for Art and Urban Resources, Long Island City, New York.
Fire as Prime Matter, Libra Gallery, Claremont Graduate School, California.
Lead/Gold Reliefs and *Season of the Fountain,* Neil G. Ovsey Gallery, Los Angeles.

1979 *California,* University of Hartford, Connecticut.
Works on Glass, Minneapolis Art Center, Minnesota.

1977 *Los Angeles of the Seventies,* Fort Worth Art Museum, Texas (traveled to Joslyn Art Museum, Omaha, Nebraska).

1975 *Transparency Exhibition,* Long Beach Museum of Art, California.
Newport Harbor Art Museum, Newport Beach, California.
Sound Tunnel, Los Angeles Municipal Art Gallery (traveled to University of Southern California, Los Angeles).

1970 *Sound in Shape of Pear,* Museum of Contemporary Crafts, New York.

1969 *357 Magnum,* Düsseldorf, West Germany.
Search Light Sky Shapes, Baxter Art Gallery, California Institute of Technology, Pasadena.
Volumetric Sound, San Francisco Art Institute.

1968 *Dry Ice,* University of California, San Diego.

1967 *Fresh Air Space,* Los Angeles Municipal Art Gallery.

Roland Reiss

Selected One-Person Exhibitions

1980 Ace Gallery, Venice, California (traveled to Ace Gallery, Vancouver, British Columbia, Canada).

1978 South Alberta Art Gallery, Lethbridge, Alberta, Canada.
Calgary Museum, Alberta, Canada.

1977 Cirrus Gallery, Los Angeles.
The Dancing Lessons/12 Sculptures, Los Angeles County Museum of Art.

Selected Group Exhibitions

1980 *Architectural Sculpture,* Mount St. Mary's College Fine Arts Gallery, Los Angeles (produced by Los Angeles Institute of Contemporary Art).
Roland Reiss and Sam Richardson, Santa Barbara Museum of Art, California.
Los Angeles Art, The High Museum of Art, Atlanta, Georgia.

1979 *Directions,* Hirshhorn Museum and Sculpture Garden, Washington, D.C.

1978 *Rooms, Moments Remembered,* Newport Harbor Art Museum, Newport Beach, California.
Miniature Narratives, University of California, San Diego.

1977 *Private Images: Photographs by Sculptors,* Los Angeles County Museum of Art.
Los Angeles in the Seventies, Fort Worth Art Museum, Texas (traveled to Joslyn Art Museum, Omaha, Nebraska, 1979).

1976 *Painting and Sculpture in California: The Modern Era,* San Francisco Museum of Modern Art, California (traveled to National Collection of Fine Art, Smithsonian Institution, Washington, D.C.).
Attitudes, California State University, Los Angeles.
Imagination, Los Angeles Institute of Contemporary Art.

1975 *Whitney Biennial,* Whitney Museum of American Art, New York.
Masterworks in Wood, Portland Museum of Art, Oregon.
Private Spaces, University of California, Irvine.

Terry Schoonhoven

Selected One-Person Exhibitions

1980 Hogarth Gallery, Sydney, Australia.
Downtown Los Angeles Underwater and Other Proposals, ARCO Center for the Visual Arts, Los Angeles.

1975 *Terry Schoonhoven Paints a Mural for the Newport Harbor Art Museum,* Newport Harbor Art Museum, Newport Beach, California (traveled to Colorado Springs Art Center, 1976; University Art Gallery, Arizona State University, Tempe, 1976; E. B. Crocker Art Center, Sacramento, California, 1977; and California State University Art Gallery, Chico, 1977).

Wall Paintings Executed Alone

1980 *Pasadena Painting,* Plaza Pasadena Mall, California.

1979 *Study in Silver,* Century City Mall, California.

1978 *St. Charles Painting,* Windward Avenue and Speedway, Venice, California.

1976 *No River,* Walker Art Center concourse, Minneapolis, Minnesota.
Adobe Gillis, Thousand Oaks Shopping Mall, California.
Study in Chrome and Gray, Rose Avenue and Lincoln Boulevard, Venice, California.

1975 *Sons of the Desert,* Newport Harbor Art Museum, Newport Beach, California.
S.P.Q.R., Bunche Hall, University of California, Los Angeles.

Selected Group Exhibitions and Wall Paintings

1981 *California—The State of Landscape,* Newport Harbor Art Museum, Newport Beach, California (Also in *A Drawing Show,* 1975; and *New Painting in Los Angeles,* 1971).
L.A. Seen by L.A. Artists, Los Angeles Municipal Art Gallery.

1977 *Illusion and Reality,* Australian Council.

1976 *The River: Images of the Mississippi,* Walker Art Center, Minneapolis, Minnesota.

1974 Betty Gold/Fine Modern Prints, Los Angeles (Also in 1973).

1971 *Hippie Know How,* Biennale de Paris.
Isle of California, Butler Avenue and Santa Monica Boulevard, West Los Angeles.

Alexis Smith

Selected One-Person Exhibitions and Performances

1981 *U.S.A.,* Holly Solomon Gallery, New York (Also window installation, 1980; *The Magic Mountain,* 1979; and in 1978 and 1977).

1980 *Raymond Chandler's L.A.,* Rosamund Felsen Gallery, Los Angeles (Also *Medium* and *The Magic Mountain,* 1978).

1979 *Stairway to Heaven,* Steirescher Herbst, Graz, Austria.
Through the Looking Glass, De Appel, Amsterdam, the Netherlands.
Autumn Sonata, Los Angeles Institute of Contemporary Art (downtown window).

1978 *The Art of Magic, Close-up* (with Tony DeLap), Baxter Art Gallery, California Institute of Technology, Pasadena.
Nicholas Wilder Gallery, Los Angeles.

1976 *Scheherezade the Storyteller,* CARP, Los Angeles.

1975 Long Beach Museum of Art, California.
Whitney Museum of American Art, New York.

1974 Riko Mizuno Gallery, Los Angeles.

Selected Group Exhibitions and Performances

1981 *Stardust,* Los Angeles Contemporary Exhibitions (LACE) (Also performed at Los Angeles County Museum of Art).
Whitney Biennial, Whitney Museum of American Art, New York (Also in 1979 and 1975).

1980 *Tableau,* Los Angeles Institute of Contemporary Art (Also in *Narrative Themes/Audio Works,* 1977 and *Autobiographical Fantasies,* 1976).
Southern California Drawings, Art School, University of Hartford, Connecticut.

1979 *Words and Images,* Philadelphia College of Art, Pennsylvania.
Paper on Paper, San Francisco Museum of Modern Art.
Decade in Review, Whitney Museum of American Art, New York.

1978 *Narration,* Institute of Contemporary Art, Boston.
Southern California Styles of the 60's and 70's, La Jolla Museum of Contemporary Art, California (Also in *University of California, Irvine, 1965–75,* 1975).

1978 *American Narrative/Story Art, 1968–78,* Contemporary Arts Museum, Houston, Texas (traveled to Contemporary Art Center, New Orleans, Louisiana; Winnipeg Art Gallery, Manitoba, Canada; and University Art Museum, University of California, Berkeley).

1977 *The American Section of the Paris Biennale,* Hudson River Museum, Yonkers, New York.
Paris Biennale, Musée d'Art Moderne de la Ville de Paris.
Contemporary Miniatures, Fine Arts Gallery, California State University, Los Angeles.
Artists' Books, Mills College, Oakland, California.

1976 *New Selections/New Talent Award Winners,* Los Angeles County Museum of Art (Also in *Margaret Lowe, Barbara Munger, Alexis Smith, Margaret Wilson,* 1972).
Los Angeles, The Museum of Modern Art, New York.
Via Los Angeles, Portland Center for the Visual Arts, Oregon.

1975 *Both Kinds: Contemporary Art from Los Angeles,* University Art Museum, University of California, Berkeley.
Four Los Angeles Artists: Foulkes, Goode, Smith, Wheeler, Visual Arts Museum, New York (traveled to Corcoran Gallery of American Art, Washington, D.C.; and Wadsworth Atheneum, Hartford, Connecticut).

1974 *Word Works,* Art Gallery, Mt. San Antonio College, Walnut, California.

1972 *Southern California Attitudes,* Pasadena Art Museum, California.

DATE DUE